W9-AHE-942

Ashmolean handbooks

English Delftware

in the Ashmolean Museum

Anthony Ray

Ashmolean Museum Oxford
in association with
Jonathan Horne Publications London
2000

Text and illustrations © The University of Oxford:
Ashmolean Museum, Oxford 2000
All rights reserved
ISBN 185444 130 2 (papercased)
ISBN 185444 129 9 (paperback)

Titles in this series include:
Ruskin's drawings
Worcester porcelain
Maiolica
Drawings by Michelangelo and Raphael
Oxford and the Pre-Raphaelites
Islamic ceramics
Indian paintings from Oxford collections
Camille Pissarro and his family
Eighteenth-century French porcelain
Miniatures
Samuel Palmer
Twentieth century paintings
Ancient Greek pottery
Glass
Turner's watercolours

British Library Cataloguing in Publication Data
A catalogue record for this book is available from the
British Library

Cover illustration: *Charger – Tulips and carnations*, No. 6

Designed and typeset in Versailles by Roy Cole, Wells
Printed in Hong Kong by Midas Printing Limited

Preface

Before the Second World War the representation of English pottery in the Ashmolean Museum consisted almost entirely of the fine salt-glaze stoneware bequeathed to the Museum by Sir Arthur Church in 1935, and it is only in the last fifty years that generous gifts and bequests have transformed the collection, notably the slipware and Staffordshire wares from Cyril Andrade, and of course the delftware here presented.

The bequest of Sir Francis Oppenheimer in 1961 included a number of English delftware plates and dishes. The gift in 1963 of the Robert Hall Warren collection, immediately established the Ashmolean as an essential centre of study for delftware. Though relatively small, the collection is remarkably comprehensive and contains a number of highly important and unique pieces. Jean Warren saw the importance of dated objects and preferred hollow wares, while Robert Warren was keen to acquire fine specimens which would illustrate the variety of decoration and form, especially the wares of his native Bristol. The bequest of F.H.A.Jahn in 1967 and of Gerald Reitlinger in 1978, together with other gifts and purchases, complement the Warren Collection perfectly to provide a notable panorama of English delftware, especially that of the eighteenth century. The major gap in the collection is a piece which would show the response of the London potters in the mid-seventeenth century to the Italo-Flemish tradition, and this is now increasingly difficult to fill.

The aim here is to show something of the variety and importance of the collection with examples from the Oppenheimer, Jahn, Andrade and Reitlinger collections as well as from the Warren Collection, a few pieces excavated in Oxford and some judicious purchases. At the same time the reader will hopefully appreciate the way in which delftware developed as an essential part of the social scene.

In 1964 I had the good fortune to be asked by Ian Robertson, then Keeper of Western Art, to write a catalogue of the Warren Collection[1]. His help was invaluable, as has been that of the present Keeper, Timothy Wilson, and of Dinah Reynolds. On specific points I acknowledge gratefully the help of Shelagh Vainker in the Ashmolean Museum, Alan Guy and Andrew Robertshaw of the National Army Museum, and Christiaan Jörg of the Groninger Museum.

[1] Museum acquisition numbers given in this book incorporate 1968 catalogue numbers; e.g. 1963.136.8 is number 8 in that catalogue

Introduction

It was some time in the ninth century in Iraq that potters discovered that by opacifying a lead-glaze with tin they produced a surface on which all manner of coloured designs could be painted and fixed in the kiln[1]. This technique eventually spread to Spain where, from the thirteenth century onwards the manufacture of tin-glazed earthenware developed rapidly, most importantly leading to the splendours of Spanish lustreware. It had also spread to Italy, but there it was only in the fifteenth century, under the influence of Valencian lustreware, that the leap forward was made from a relatively simple ware to the complexities of Italian maiolica[2]. This now set the standard and potters everywhere strove to master the technique and imitate the style. In Northern Europe the vital role was played by Italian potters who emigrated to Antwerp shortly after 1500. The most important of these was Guido di Savino, a potter from Castel Durante who became known as Guido Andries and produced a family of potters who then moved to other countries.

The earliest certain date in the history of English delftware is 1570, when Guido's son Jasper Andries, who, with Jacob Jansen, had come to Norwich in 1567 to escape religious persecution, applied for a patent to make tin-glazed earthenware. In their application they mentioned that Henry VIII had invited Guido to come and work in England, but that nothing had come of it. The petition was unsuccessful, probably because a group of Lincolnshire noblemen had also applied for a patent. Jansen came to London where, with other Flemish potters, he worked in Aldgate. In about 1618 a notable factory was established at Pickleherring Quay in Southwark by another immigrant potter, the Dutchman Christian Wilhelm, employing both Dutch and English workmen, and there was also a pottery at nearby Montague Close. New potteries sprang up at the end of the century, some of them also employing Dutch workmen and the industry continued to flourish in London in the eighteenth century, producing good quality wares until the 1790s, with two potteries continuing to operate in the early nineteenth century.

The problems faced by nonconformists in London led to the emigration of delftware potters to Brislington, near Bristol, in the 1640s, where they established a thriving pottery. However, in the early eighteenth century, Brislington rapidly lost ground to the city of Bristol where there were four factories, the most important of them being that of Thomas Frank on Redcliff Backs, where

some of the finest Bristol delftware was made, especially after 1757, under the direction of his son, Richard. The pottery at Wincanton in Somerset, which operated in the 1730s and 1740s, was probably staffed by workmen from Bristol. It was potters from Southwark who set up the first delftware potteries in Liverpool c.1710, and in the following years the industry developed there rapidly: by 1750 there were nine factories in operation, producing some of the most attractive pieces of delftware made in the British Isles. Factories were also established at Delftfield in Glasgow and in Dublin in the mid-eighteenth century[3]. The fashion for delftware in the British Isles lasted until the 1770s, when creamware came to dominate the market.

Delftware was never cheap. The hazards of firing meant that less than half the pieces could be sold at full price and this, together with the laborious process of decoration, added to the cost. There was also the problem of fragility. Though the pottery body is robust enough, the glaze is liable to chip and craze, and it proved to be totally unsuitable for serving very hot liquids. Nevertheless it had the advantages of being bright and clean and, above all, decorative. It was therefore highly attractive to a surprisingly broad clientèle. The aristocracy may have preferred to eat off silver, but in the seventeenth century at least they commissioned special pieces from the delftware potters. The gentry became important patrons in the eighteenth century, and at all times the rich tradesmen, members of the flourishing guilds and other well-to-do folk favoured delftware, sometimes embellished with a coat of arms. It was naturally a very suitable form of pottery for commemorative pieces of all kinds, since it is a simple matter to add the name or initials of the owner together with the date to celebrate, for example, a birth or a marriage, or the occasion of becoming a freeman of a guild, or to wish prosperity to a commercial venture. At the same time there is evidence that in humbler homes a particular piece of Delftware, such as a charger, was a treasured possession brought out on special occasions and handed down as an heirloom.

One of the most remarkable things about the delftware pottery industry was the way in which it tried to cater for every possible domestic need. Something of the variety of the production can be seen from the selection here presented. The plates, dishes, tureens and smaller objects such as sweetmeats and gravy-boats would have been handsome features of a dinner table, as the service laid out at Williamsburg shows so effectively[4]. All the necessary vessels were made for serving tea and coffee: apart from the tea-pots and caddies shown here, and the very rare coffee-pot[5], the Warren Collection has four tea-bowls and saucers. There were wine-cups, posset-pots, punch-bowls, tankards and mugs for stronger liquids; storage jars for spices and other commodities; vases, wall-pockets and 'flower-bricks' for showing off cut blooms; barber's basins, bleeding-bowls and wash-basins with bottles *en suite*; ink-stands and pounce-pots for the writing desk; and puzzle-jugs for tempting the unwary.

More intriguing objects are the 'toys' such as hand-warmers and the shoes which, together with a few rare figures, show the ability of the potters to work from moulds. An apothecary could be supplied with drug-jars[6], pill-tiles and ointment-pots. Other objects recorded in the literature include splendid baskets with pierced sides, money-boxes, watch-faces and clock-cases, buttons, and, most unusually, a butler's tray with partitions for cleaning materials, presented no doubt on his appointment on Lady Day[7]. This list is by no means exhaustive, and one should remember also that huge quantities of tiles were made.

In terms of decoration, apart from heraldic and 'royal' motifs, and the wares commemorating historical events, the potters were imitators and adapters rather than innovators. In the years around 1600 the Flemish potters in London naturally worked in the Flemish style. In the early seventeenth century Christian Wilhelm responded to the new fashion for *chinoiserie* derived from Ming porcelain[8] and at the same time there was an effort to imitate the polychrome figure subjects of the Italo-Flemish tradition together with the simpler designs found on Dutch pottery before the rise of Delft in the second half of the century. The austerity of the Commonwealth is reflected in the popularity of plain white wares[9], but after the Restoration fashions turned once more to *chinoiserie*, now based on Chinese export wares[10], while a distinctive group of pieces with decoration in white on a deep blue ground, owes much to Nevers. Compared with the splendours of Delft pottery, particularly the fine products of the 'Greek A' factory patronised by William III and other members of the court, seventeenth-century English delftware, however attractive, appears somewhat unsophisticated.

The eighteenth century saw a greater variety of decoration and a growing assurance in realising quite complex designs. Early on the influence from Delft can be felt in the landscape decoration with figures and sponged trees[11] which remained in favour throughout the delftware period. Equally popular was 'Chinese' decoration based on Kangxi porcelain decorated with figures illustrating romances[12]. Much use was made of formal floral and geometric patterns, and a whole group of wares, sometimes called 'farmhouse plates', painted in a summary style with simple motifs of all kinds, apart from *chinoiserie*, was made for a modest clientèle. As in the seventeenth century, sets of six plates were made, each with a line forming part of a rhyme[13]. Towards the middle of the century the influence of Rococo made itself felt, not only in a more subtle feeling for landscape, but, most significantly in the taste for fanciful *chinoiserie*, inspired by the work of Pillement and others, which produced some of the most attractive objects in English delftware. Exotic birds, perhaps imitating Chelsea and Worcester, appear on boldly painted plates, and on other pieces stylised flowers show off the brilliance of the polychrome palette. For the more complex subjects engravings continued to be used, usually pricked

through for use as a transfer: the 'Flower bowl' is a notable example[14]. Sometimes the decorative effect is enhanced by special techniques such as a coloured ground, applied by covering areas of a vessel with a fine powder, usually manganese purple or blue, leaving reserve panels where necessary for further decoration or providing a ground for scratched motifs (*sgraffito*)[15]. Another vivid effect was produced by superimposing designs in white on a tinted ground, the so-called *bianco-sopra-bianco* technique[16], and, in an attempt to rival porcelain decoration, some pieces were decorated with high-temperature enamel colours and fired in a muffle-kiln. It should also be remembered that a great deal of delftware was sold undecorated.

The high quality of so much of the pottery made in Delft in the late-seventeenth century can largely be attributed to the fact that the best decorators were members of the Guild of St Luke, the painter's guild, which no doubt set the highest standards. In England there appears to be no such connection between 'art' and 'craft'[17], yet the factories produced a ware which was highly acceptable to their clientèle. English Delftware makes up for any relative lack of refinement by its spontaneity and honesty, and by its variety. This is a colourful world of useful and much-used objects, whose designs reflect the changing fashions and some of the preoccupations of the age. Many of them became heirlooms, a part of family history. That world may have come to an end with the development of cheaper and more durable industrial bodies, but it lives on splendidly in the collection of the Ashmolean Museum.

[1] J. W. Allan, *Islamic ceramics* (Ashmolean handbooks), 1991
[2] T. Wilson, *Maiolica* (Ashmolean handbooks), 1989
[3] There are no certain pieces of Scottish or Irish delftware in the Ashmolean collections
[4] Austin, 1994, p.33
[5] No.17
[6] There is a good collection in the Oxford Museum of the History of Science
[7] Horne, *Collection*, Part III, No.60
[8] cf. No.1
[9] No.2
[10] Nos.11–13
[11] Nos.14, 15, 16
[12] Nos.31, 32
[13] A 'Merryman' set is in The Warren Collection (Ray, 1968, No.52)
[14] No.29
[15] No.26
[16] Nos.35, 36, 37, 45, 46
[17] It is ironic that among the finest examples of painting on delftware are the plates decorated in Delft by Sir James Thornhill (now in the British Museum)

1 Deep dish with Ming motifs

London, Southwark – Pickleherring Quay
(Thomas Townsend or Richard Newnham) or
Montague Close, c.1640–50

In January 1628 Christian Wilhelm, the owner of the Pickleherring pottery, was granted the monopoly of delftware manufacture for a period of fourteen years, but he died in 1630 and was succeeded by his son-in-law, Thomas Townsend. In his petition Christian Wilhelm claimed he had 'invented the making of white earthern pots, glazed both within and without, which show as fair as China dishes'. Obviously he had not invented tin-glazed earthenware, but he was evidently the first in this country to apply Chinese decoration to his products. This was in accord with the contemporary enthusiasm for Chinese porcelain resulting from its sudden availability thanks to the Portuguese merchants, the Dutch east India Company and the sale of captured cargoes in 1602 and 1604[1]. A series of wares with dates ranging from 1628 to 1630 survive, decorated with a motif known as the 'bird on the rocks': this aptly named motif is accompanied by leafy fronds and a distinctive flower with petals terminating in blobs. There is no piece of this kind in the Ashmolean collection. Although Pickleherring is associated above all with monochrome blue wares, we know from his patent that he also made polychrome ware, but few examples have survived, the most remarkable being the 'Samson and the Lion' jug in the British Museum on which European figures and *chinoiserie* go hand in hand.

The Chinese style continued after Christian Wilhelm's death and a date in the second quarter of the century is suggested for a number of dishes of the type seen here, with simplified motifs taken from the typical compartmented border of Wan Li dishes and a central flower-like motif which is also common on Netherlandish pottery. Hume illustrates several dishes of this type together with fragments found in St Olave's parish, Southwark, though not a known pottery site, and similar fragments have been found in America[2], where Christian Wilhelm had trading connections via the Virginia Company. The present bowl, excavated at Carfax, Oxford, in 1938, is the only recorded archaeological find of such ware in England outside London: like many dishes of this type, it has a lead-glazed back with traces of cobalt.

d. 248 mm; h. 74mm. ANT 1938.1169

[1] The earliest copies were made in Portugal in the late sixteenth century
[2] Hume, 1977, p.45f

8

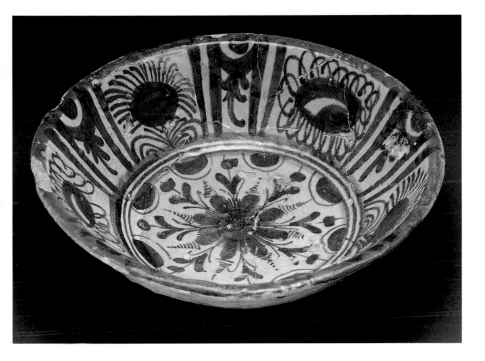

2 Posset-pot
London, (Pickleherring or Montague Close)
Inscribed E M 1653

This, the earliest dated piece of delftware in the Ashmolean, is traditionally called a posset-pot. Posset was made from milk, wine or ale, sugar and spices: the liquor curdled the milk and it was the alcoholic curd which was then sipped through the spout on the front of the vessel. It was a fashionable drink throughout the seventeenth century and one which had social significance, hence the elaborate decoration, particularly *chinoiserie*, found on many examples, with dates ranging mainly from 1631 to 1712: Pepys, for instance, served posset at a party in 1668. A late seventeenth-century author refers to such vessels as 'a posset pot, or a wassell cup, or a sallibube pot', thus indicating that it was used for wassail and syllabubs, and to these closely related alcoholic concoctions one should add caudle. Anthony Wood in his *Athenae Oxonienses* mentions that at Merton College it was the custom on Shrove Tuesday for a freshman to give a speech which, if well received, was rewarded with 'a cup of cawdle'. On the other hand posset and caudle were also prescribed as a cure for colds and other minor ailments, and undecorated posset-pots may have been made for this purpose.

Posset-pots vary greatly. The shapes echo silver or pewter prototypes, the earliest being tall and straight-sided, the later ones bulbous. All had lids, and at the end of the century these were sometimes fashioned in the form of an elaborate crown. The average height of a posset-pot was 150–200mm, but small possets were made for children (No.*12*).

The present example is typical of London delftware in the middle of the seventeenth century, particularly during the Commonwealth, when the potters were often content to allow the rich tin-glaze to set off a simple type of decoration such as a coat of arms or, as here, a triangle of initials indicating a husband and wife. A very similar posset-pot, inscribed 'A S 1653' is recorded[1] and both these have the same kind of debased Mannerist grotesques supporting the panel with the inscription. Indeed the close similarity of the potting and the decoration suggests that they were made in the same factory and painted by the same decorator. The rather squat shape, derived from a metal original, is unusual among surviving specimens.

[1] Lipski & Archer, 1984, No.892

h. 112mm; w. (max.) 256mm. Marshall Collection. WA 1986.21

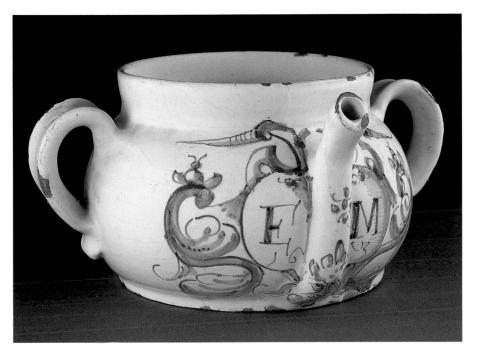

3 Charger Adam and Eve
London (probably Southwark), 1650–1660

A considerable number of 'blue-dash chargers'[1] have survived depicting the Temptation, an indication both of the popularity of the subject in the seventeenth and eighteenth centuries and of their importance as heir-looms in later times.

The earliest dated example, in the Victoria and Albert Museum[2], is of 1635, and is clearly based on an undated engraving by Crispin van de Passe (1564-1637) which was much used in illustrated bibles as well as providing the model for most of the Adam and Eve dishes of the seventeenth century and some of the eighteenth century as well. These include one dated 1640 in the Fitzwilliam Museum and one dated 1650 formerly in the Lipski Collection[3]. A comparison of these dishes shows that the present dish is better drawn than any of them – admittedly a relative term in view of the anatomical distortions – notably the heads. The distinctive striated foreground in yellow and green is closer to that seen on the 1650 dish than it is to the very simplified form found on later dishes, and it is likely that this dish dates from the 1650s.

At the end of the seventeenth century Adam and Eve chargers were also made in the Bristol area. On some of these the figures are derived from an engraving by Pierre Lombart which appears in a Bible published by J. Field in Cambridge in 1659: here the figures are seen from the front with hands raised[4]. On other versions the figures step towards each other with one arm outstretched and on an example from the Bristol area in the Warren Collection[5], datable to c.1720-30, the badly-drawn figures strike yet another pose. Also from Bristol are polychrome plates, as distinct from chargers, including two dated 1741[6] which follow the second Bristol type mentioned above, as do a few other plates.

The subject is rarely found on other types of vessel. Adam and Eve appear as small isolated figures on a caudle-cup in the British Museum dated 1655, and on a posset pot dated 1669[7]. This is not surprising, since these chargers clearly had first and foremost a decorative function and were perhaps only used on special occasions, since they rarely show any signs of wear.

Like most seventeenth-century dishes this one has a lead-glazed back.

[1] So called because of the distinctive border of slanting dashes round the rim
[2] Archer, 1997, A.13
[3] Lipski & Archer, 1984, Nos.3, 22
[4] Britton, 1982, Fig.2
[5] Ray, 1968, No.9
[6] Lipski & Archer, 1984, Nos.474, 474A
[7] Lipski & Archer, 1984, Nos.732, 897

d. 406mm; h. 89mm. Warren Collection. WA 1963.136.8

12

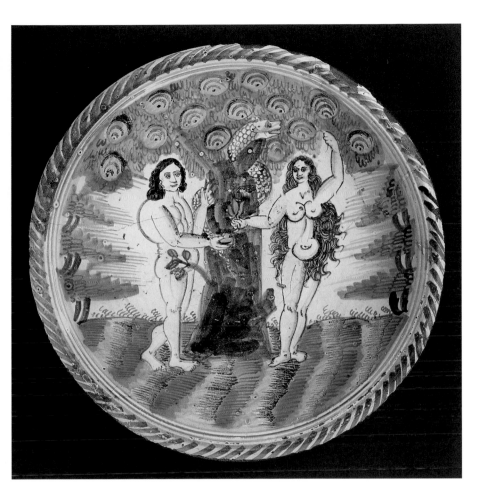

4 Charger – Charles II
London, dated 1665

The English monarchs from Charles 1 to George III appear on a considerable number of 'blue-dash chargers' as well as on other wares such as plates, mugs and wine-cups. Clearly engravings, some of them identified, served as a basis for a partial portrait, but often enough they provided an effigy, bordering on caricature, only identifiable by the initials accompanying the figure. These decorative pieces, made either as coronation souvenirs or expressions of loyalty, are well represented in the Ashmolean collection though the gallery of monarchs does not include Charles I, James II or George III[1].

Three chargers depicting Charles I are known, all of them dating from after his execution. The most notable of these is the 'Chequers' dish of 1653, now in the Victoria and Albert Museum, where the King, standing under an arcaded vault, is accompanied by his children, Prince Charles, Prince James and Henry, Duke of Gloucester[2]. Charles II appears on a number of chargers, with dates ranging from 1661 to 1673[3]. On many of these the king, like Charles I on the Chequers dish, stands in an arcaded vault with a lattice pattern suggesting a tiled floor, as seen here: on others the chequered floor is more carefully drawn. On another dish in the Warren Collection[4] the figure of Charles II as seen here is shown, but in reverse, standing in a landscape with a striated foreground similar to that on the cock charger (No.7). On a dish dated 1669 he is shown accompanied by Catherine of Braganza[5].

Like most seventeenth-century chargers, this example has a lead-glazed back, here of brownish tone.

Among the table-wares depicting Charles II the earliest are a wine-jug, a tankard and two caudle-cups dated 1660, but a plate in the Warren Collection (Fig.1) may also have been made soon after the King's accession. It is apparently the only known plate depicting the monarch, though several other cups, bottles and other vessels, dated and undated, show his effigy. On nearly all these pieces the king is drawn in exactly the same way, clearly from a common original.

Most surviving examples of royal delftware appear to be of London make, but some rather more clumsily drawn royal pieces in monochrome blue were made in Brislington.

d. 311mm; h. 57mm. Warren Collection. WA 1963.136.1

[1] Few pieces depicting James II have survived, and George III occurs only on a few plates: one at Williamsburg is illustrated byAustin (1994, No.190)
[2] Lipski & Archer, 1984, No.26. The others are at Waddesdon and Williamsburg (ibid. Nos.30, 33)
[3] Lipski & Archer, 1984, Nos.38-42, 48, 50, 51, 56, 58, 62
[4] Ray, 1968, No.2
[5] Lipski & Archer, 1984, No.56

Fig.1. Delftware plate, depicting Charles II London, 1660–1665 Warren Collection. WA 1963.136.18

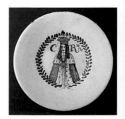

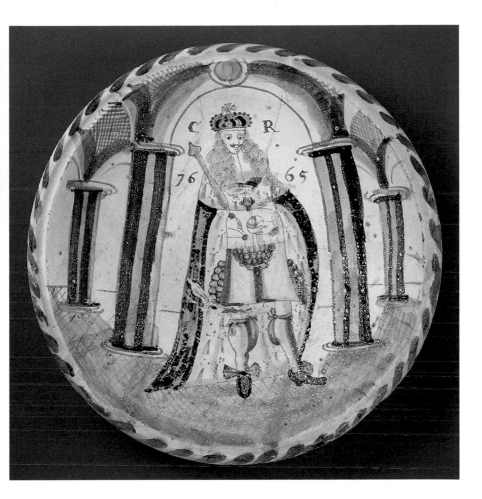

5 Dish, George I (1714–1727)
Probably Brislington or Bristol

The initials apparently read G[s] R for Georgius Rex and the same figure, taken from some untraced engraving, served for both George I and George II, the last monarch to be portrayed on dishes of this type. All the decorator had to do was to add the 'II' above the crown to distinguish him from his father, as can be seen on a dish in the Glaisher Collection and on one at Williamsburg[1]. As George II, with the 'II' added, he appears on another dish in the Glaisher Collection and on one formerly in the possession of Jonathan Horne[2]. These four dishes are closely similar, differing only in minor details such as the facial features, and all must derive from the same pricked transfer giving the main outlines. The style of decoration is reminiscent of the 'farmhouse plates' of the period with typical sponged trees painted in tiers.

The decorative quality of this dish is greatly enhanced by the rich red used to pick out details and to paint the stockings. The colour, derived from iron oxide, became very popular in the early years of the century, both in England and Holland.

Unlike the seventeenth-century royal chargers, this dish has a tin-glazed back.

The Warren Collection also has an unusual small charger depicting George II in armour standing in a landscape, in a style more often found with effigies of Queen Anne and her generals[3].

d. 330mm; h. 73mm. Warren Collection. WA 1963.136.6

[1] Rackham, 1930, No.1639: Austin, 1994, No.185
[2] Rackham, 1930, No.1638. Horne, *Collection*, Part II, No.34
[3] Ray, 1968, No.7; cf. below, No.7

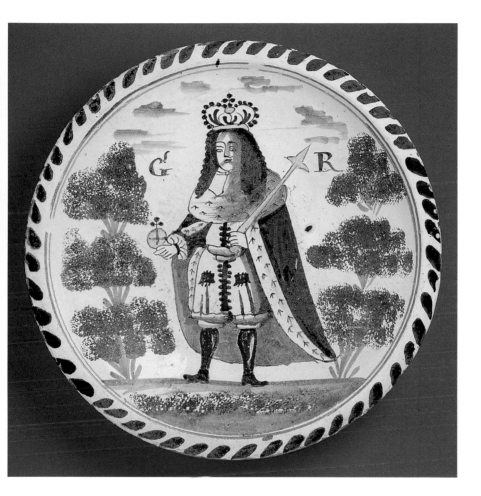

6 Charger – Tulips and carnations
London, 1675–1690

Some of the most attractive late seventeenth-century chargers are decorated with tulips, either placed in a distinctive globular pot or else growing from a mound. Only four dated examples are recorded, with dates ranging from 1661 to 1676, which suggests they were especially popular in the reign of Charles II[1]. However, as one might expect, the design originated in Holland in the late sixteenth century and, in the land of tulipomania, immediately became a common form of decoration[2]. A fragmentary Netherlandish dish of this type, with a single tulip, dating from the first quarter of the seventeenth century was excavated on the site of the New Schools in the High St, Oxford (Fig.2)[3]. Tulips became a common motif in the English decorative arts, but they do not seem to have appeared on delftware dishes before the middle of the century. Apart from the clearly established links with Dutch pottery it is also possible that there was some influence from Iznik pottery of the sixteenth and seventeenth centuries. Iznik jugs with sixteenth-century silver mounts are known and there are other contemporary references to Turkish pottery in English houses, while a fragmentary Iznik dish was excavated at Waltham Abbey in a late seventeenth-century context[4]. Moreover the petition of 1570 by a group of Lincolnshire noblemen was to make 'erthen woorke after the manner of Turkye Italye Spayne and Netherlond'.

English tulip dishes vary greatly in quality since they were evidently painted free-hand by decorators of uneven ability. The present example, like a very similar dish formerly in the Morgan Collection[5], is one of the most assured and is in its modest way a masterpiece of ceramic decoration. It will be noted that the blue-dash border here includes small circles, a feature occasionally found on other chargers of this period, and it has a lead-glazed back.

d. 330mm; h. 37mm. Warren Collection. WA 1963.136.16

[1] Lipski & Archer, 1984, Nos.37, 45, 53, 66
[2] Biesboer, *Nederlandse Maiolica*, 1997, pls. 150–154, the last one dated 1632
[3] See also Rackham, *Early Netherlands Maiolica*, 1926, pl. 22
[4] *Post-Medieval Archaeology*, Vol. 3, 1969, pl. 1
[5] Archer & Morgan, No.21

Fig.2. Fragmentary delftware dish. North Netherlands, 1600–1625
ANT 1876.91

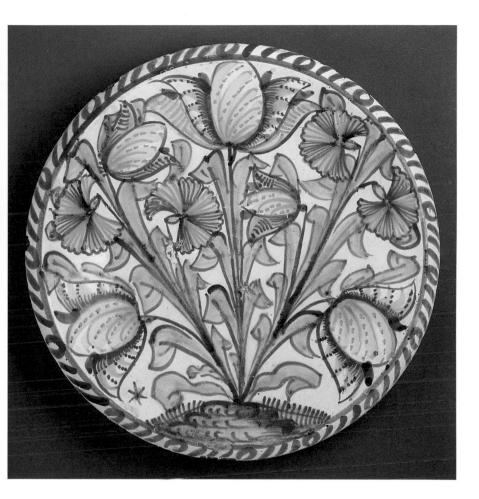

Later chargers

7 A cock in a woodland
Probably London, 1700–1720

Among the less common designs on these chargers few are more attractive than this one, or better painted. The decorator has skilfully brought the crowing cock to life and, in his depiction of the tail, displayed bravura brushwork of a kind rarely seen on delftware.

The whole style of decoration is typical of the chargers of the early eighteenth century, with blue sponged trees and a foreground consisting of leafy fronds on a turquoise-green ground, as seen on other examples in the Warren Collection[1]. The bright contrast of the red and yellow is characteristic of the period and the reverse has the thin tin-glaze which replaced the lead-glaze found on seventeenth-century dishes.

Chargers with this kind of landscape were probably made in London. Among the shards excavated on the site of the Vauxhall pottery is a bowl with an identical bird painted in blue flanked by tiered trees[2]. Certainly it is less well painted, but the effect is very close to that seen here.

[1]Ray, 1968, Nos.4, 5, 7. These show Queen Anne's generals and George II
[2]Britton, 1987, pl.70H

d. 350mm; h. 64mm. Warren Collection. WA 1963.136.13

8 'The Green Man'
Probably London, 1700–1720

Figure subjects apart from royalty are very rare on these dishes, and the green man is the most intriguing. A label on the back of this dish reads, 'From the time of Elizabeth onwards the Green Man used to walk in processions and fight with men similarly attired, or attack dragons and castles. The Green Man was frequently found on sign-boards.' There are indeed many inns called the Green Man, for which such a dish would be appropriate, but their signs have more to do with a Jack-in-the-green or 'woodhouse', a familiar figure clad in green leaves who took part in spring festivals. This half-naked figure with a club looks like Hercules, but such a classical figure would be exceptional on delftware.

The 'wickerwork' foreground and thin tin-glaze on the reverse are characteristic of early eighteenth-century chargers attributed to London.

d. 362mm; h. 73mm. Warren Collection. WA 1963.136.12

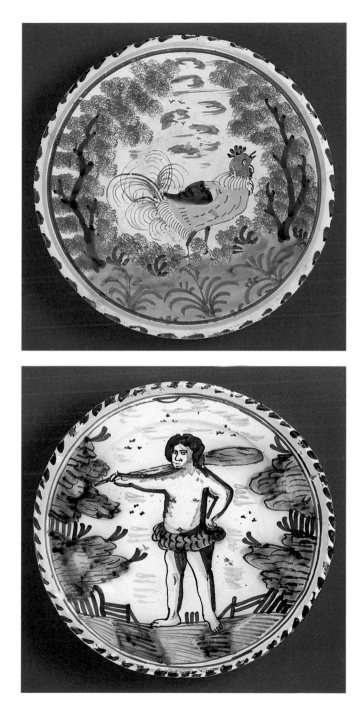

9 Book ('hand-warmer')
London, dated 1672, inscribed (on the 'fore-edge) E.C.

Objects of this kind, in the form of a book, have been called hand-warmers for use in cold weather, though there is no evidence to support this belief. Italian and Dutch examples are known – one of the latter has the arms of Amsterdam and the date 1651. Some of these vessels are hollow and could be filled via a spout[1], but in this example from the Warren Collection there is a partition which seals off half the vessel completely, apart from a tiny hole in the side. Clearly, then, it was not a container and could well have been a novelty gift like those inscribed 'The Gift is small, Good will is all.'

In English delftware the earliest recorded dated example is of 1653, the latest of 1710[2]. For the most part they are painted to look like a book with a tooled binding and metal clasps, but one example, dated 1665, has a rustic scene on one 'cover'[3]. The Warren example is unusual in that it has two lengthy inscriptions –

'Toe poters clay thou takest me to be:
Remember then thy one mortalyty'

'Earth I am it is most trew
Disdain me not for soe are you'
The second inscription is echoed on a sack-bottle of 1661 which reads 'You and I are earth'.

h. 127mm; w. 37mm; t. 38mm. Warren Collection. WA 1963.136.45

10 Plate – The Crucifixion
London, dated 1698

Although countless biblical tiles are known, very few pieces of delftware with religious subjects have survived. Seventeenth-century examples include a plaque in the Glaisher Collection, dated 1686, depicting 'Lot and his daughters'[4], a basket dated 1698 depicting 'Jacob wrestling with the Angel', a plate dated 1692 depicting 'Balaam and the ass'[5], and this plate.

Like the Balaam, the representation of the Crucifixion is evidently based on a typical seventeenth-century tile Dutch design taken from an engraving[6]. A fragment of a similar plate, dated 1701, was found by Garner in Lambeth.

d. 226mm. Warren Collection. WA 1963.136.53

[1] Cf. An Italian maiolica example in the Ashmolean Museum (WA 1956.69)
[2] Lipski & Archer, 1984, Nos.1762, 1772
[3] Lipski & Archer, 1984, No.1766
[4] Lipski & Archer, 1984, No.1553
[5] Horne, Collection, Part XIV, No.388
[6] Pluis, Bijbeltegels, 1994, No.1691 (and cf. No.1690)

22

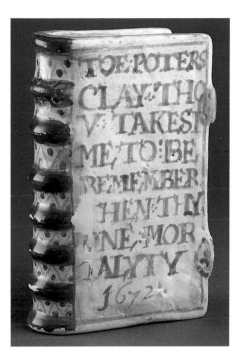

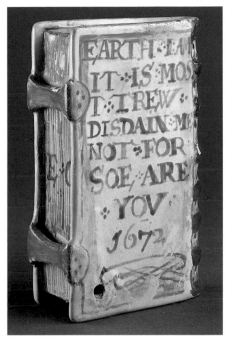

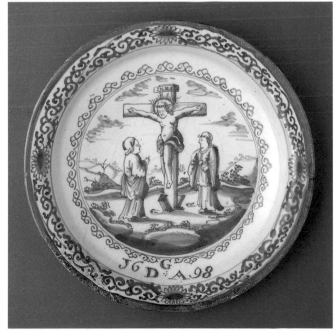

11– 13 Late seventeenth-century *chinoiserie*

The earliest *chinoiserie* style on English delftware has already been discussed (No.*1*). In the middle years of the century such influence was negligible, but in the final third there was a revived interest in the kind of motifs provided by late Ming and 'Transitional' Chinese porcelain (Fig.3). Huge quantities of wares were decorated with figures set in a landscape dominated by rocks and large plants. On the finest pieces in this style there is a certain coherence in the design, but the majority of these pieces show a shorthand version of the style, as seen here. The earliest recorded date on such a piece is 1669, found on a caudle-cup in the Fitzwilliam Museum[1], while the forms include plates, both round and octagonal, cups, bowls, possets and mugs, and flower-vases.

The octagonal plate (No.*11*) is one of four with the same initials and date, presumably forming part of a service. Britton's researches show that on 14 February 1679/80 a certain William Davis, Grocer, married Dursabella Horne in All Saints church, Bristol, and that there was an Isaac Davis who had been trained as a potter, taking on an apprentice in 1694. There could well be a family connection here. Plates of this kind are found in blue, blue and yellow, manganese and yellow (Fig.4) and, more rarely, in green and manganese.

The small mug (No.*13*) excavated in Oxford, is an unusual survival, as are the small posset, possibly made for a child (No.*12*), and the small vase and jug also in the Warren Collection[2]. Pieces in this style were made in both London and the Bristol area, and, in the absence of documentary proof of origin, a firm attribution is impossible.

11 Octagonal plate, dated 1679
w. 210mm. Probably Bristol. Oppenheimer Gift. WA 1961.57.16

12 Child's posset-pot, 1675–1700
w. 136mm; h. 76mm. Bristol or London. Warren Collection. WA 1963.136.119

13 Mug, 1675–1700
d. 64mm; h. 61mm. Bristol or London. Excavated in Oxford. 1937.976

[1] Lipski & Archer, 1984, No.768
[2] Ray, 1968, Nos.120, 121

Fig.3. Porcelain ewer with silver mounts Chinese export ware, 1645–1665 (the mounts eighteenth-century) Reitlinger Gift. EA 1978.1938

Fig.4. Octagonal delftware plate London or Bristol, 1675–1700. Reitlinger Gift. WA 1978.246

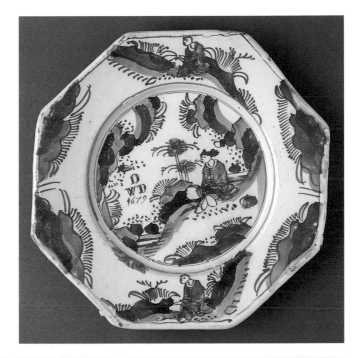

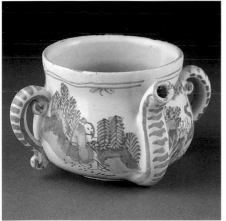

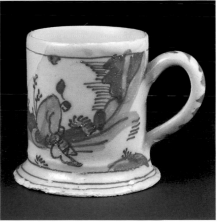

14 Bowl – the Marching Men
London, 1690–1700 or a little later

This unusual punch-bowl is a very rare survival, quite unlike any other surviving piece of delftware apart from a fragment of a similar bowl found by Garner on a Lambeth site. This fragment, presumably a waster, shows that the bowl once had companion pieces and that it was made in London.

The decoration, derived from some military manual, not yet identified, is of the highest quality. The outside shows a company of infantrymen formed in four ranks with a captain carrying a half-pike leading a detachment of musketeers with a drummer between the third and fourth files, and in the rear an ensign leading a detachment of pikemen. In terms of contemporary military practice this would be too small for a real foot company but it would have been difficult to include more soldiers in the space available. However, the ratio of pikes to muskets and the position of the officers is correct for such a company at the end of the seventeenth century. The uniforms, of 1680–1700, were worn by both English and continental troops, and any army in the early part of the War of the Spanish Succession would have included companies of musketeers, but pikes were no longer in use in the English army after 1703[1]. The three groups are divided by sponged trees and inside the bowl four non-military figures stand or sit in a landscape with similar trees. Round the foot and the inner landscape is a circle of *ju-i* scrolls derived from Chinese porcelain, a seemingly incongruous mixture of East and West which is however characteristic of the period. The bowl evidently received a final lead-glaze finish (*kwaart*) giving it a very shiny surface. This was a Dutch technique also found on early eighteenth-century English wares, and it is likely that this bowl was decorated by one of the Dutchmen known to have been working in London during the reign of William III.

By analogy with the Samuel Campion bowl of 1734[2], this bowl and its presumed companions may have been made for the officers of a regiment. It is, however, odd that such a special piece is neither signed nor dated.

[1] All this information kindly supplied by Dr Alan Guy and Andrew Robertshaw of the National Army Museum
[2] Ray, 1968, No.61

d. 305mm; h. 140mm. Mark (under the base): 36 (perhaps a decorator's mark). Warren Collection. WA 1963.136.57

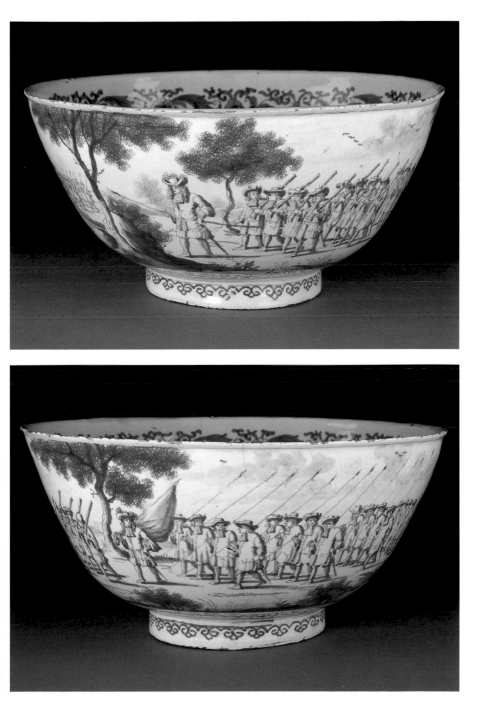

The 'Dutch' style

15–
16 Dish and flower-brick
Probably London, 1700–1725

The rare plaques and dishes painted in Delft by Frederick van Frijtom are certainly the finest manifestations in pottery of the Dutch landscape tradition, but there were other decorators who showed a remarkable feeling for landscape expressed in a subtle use of different shades of blue. Fine examples from the Greek A factory were brought to England in the 1690s, notably the milk-pails, marked A K for Adrianus Kocx, made for Queen Mary's dairy at Hampton Court (now in the Victoria and Albert Museum), and a dish at Dyrham Park marked S V E for Samuel van Eenhorn.

In the first quarter of the eighteenth century the Dutch influence on English delftware decoration was very strong and there is good documentary evidence to show that Dutch potters were employed in the London pot-houses working alongside their English counterparts. Fragments of pieces with 'Dutch' landscapes have been excavated in Southwark and in Lambeth, including one dated 1710[1], but there is also evidence that the style was current in Brislington. The most notable London examples are the crowned posset-pot in the Liverpool Museum dated 1702 and the 'Swan Inn' bowl formerly at Rous Lench dated 1718[2]. Common to all these and other pieces, such as the posset-pot in the Warren Collection[3], are the manner of drawing trees with a small sponge to give a dense, smudged effect which is very different from the more meticulous drawing of the finest Dutch examples, and the somewhat rudimentary approach to perspective.

The dish (No.15) which shows men with spades is typical, and the figure on the left is reminiscent of one seen on English tiles of the 1720s. The other piece (No.16) has a number of holes on the top and is an early example of a 'flower-brick' used to display cut flowers. It has a continuous decoration, with different figures on all faces. A comparison of this piece with the well-known 'flower-brick' from the 'Greek A' factory in the Rijksmuseum, Amsterdam, shows clearly the relative clumsiness of the London decorators.

[1] Archer, 1997, F.5
[2] Lipski & Archer, 1984, Nos.943, 1056
[3] Ray, 1968, No.56

15 The dish:
d. 332mm. Mark: 2. Reitlinger Gift. WA 1978.197

16 The flower-brick:
l. 237mm; h. 120mm. Reitlinger Gift. WA 1978.245

17 Coffee-pot
London, dated 1705

Coffee came to Europe from the Middle East in the early seventeenth century, reaching England in the second quarter. Coffee-houses became fashionable and one of the earliest recorded was in Oxford, as recorded by Anthony Wood in his *Athenae Oxonienses* – 'In 1650 Jacob, a Jew, opened a Coffey House at the Angle (?Angel) in the parish of St Peter in the East, Oxon, and there it was by some who delighted in novelties drunk'. In the course of the next fifty years they sprang up in every large town. The new beverage gave rise to new utensils, in the first instance made of metal, but, as the demand spread, the potters took up the challenge. In the delftware sections of the Pickleherring inventory of 1699 we find mention of 'coffees', 'chocoletts' and 'capucheens' (various types of cup) and of 'sawcers', but no mention of coffee-pots. These appear in the section headed 'stone ware'. Clearly they had learnt by bitter experience that delftware is an unsuitable type of pottery for serving very hot liquids, and that stoneware, or of course metal, served the purpose far better. Two such vessels are in the British Museum[1], both of them of similar shape to No.*17*, differing only in the profile of the lid. A silver coffee-pot made by the Huguenot silversmith Jean Chartier, bearing the hall-mark for 1700, has a conical lid. On a rare white-dipped stoneware example, made in London or Staffordshire, the lid is slightly curved, but not dome-shaped.

The Ashmolean coffee-pot is therefore a remarkable object. Not only is it the only dated example, it is one of only two known delftware examples to have survived, the other being a rather later pot in the Bristol City Art Gallery, of similar shape but with the handle and spout in line as opposed to being at right-angles[2]. A tin-glazed stoneware example is in the Liverpool Museum[3]. The decoration of the Warren coffee-pot, vaguely Oriental in inspiration, is typical of the period, appearing in very similar form on other pieces, notably the Ruth Twiss punch-bowl in the Metropolitan Museum, New York, also dated 1705[4], and the fine urn at Colonial Williamsburg.[5] There is a small blue ring on the lid to which a silver chain was attached: this chain apparently became detached and was lost in 1930.

h. 191mm; w. (max.) 118mm. Warren Collection. WA 1963.136.124

[1] Hugh Tait, 'The earliest ceramic coffee-pot', in *Ars Ceramica et Artes Glaesum*, No.4, 1987: Wedgwood Society of New York, p.50f
[2] Britton, 1982, 9.13
[3] Garner & Archer, 1972, pl.115A
[4] Lipski & Archer, 1984, No.1045
[5] Austin, 1994, No.611

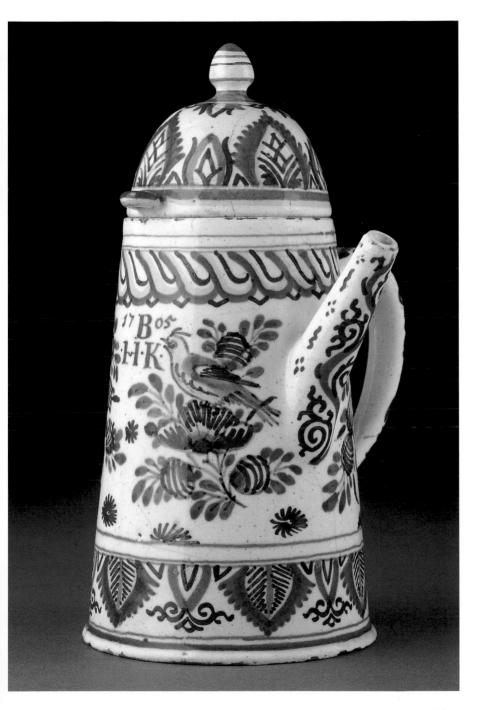

18 Teapot
London, 1700–1715

Tea was introduced into England shortly after coffee, the earliest known advertisement being of 1658[1]. Catherine of Braganza introduced the beverage to the court c.1660 and the East India Company began to trade in tea in 1678. It was at this time an expensive luxury which was also credited with medicinal powers. After 1700 tea became more generally available and there was a huge increase in demand despite heavy taxes.

The fashion for tea coincided with the fashion for Chinese porcelain which was seen as a necessary adjunct for reasons of practicality as well as prestige: silver cups were simply too hot to hold. Naturally the potters tried to cash in on the new fashion, using their traditional materials since porcelain was still an oriental mystery. In the seventeenth century redware was considered to be the most suitable material for teapots, and these were made by John Dwight in Fulham[2] and the Elers brothers in Staffordshire, who, like Ary de Milde in Holland (Fig.5), took Xi-Hsing originals as their models. No delftware teapots from the seventeenth century are known, nor any dated examples from the early eighteenth century.

This teapot, of tall hexagonal shape is a very rare survival: indeed no other teapot of this shape appears to be recorded either among the redware examples from Holland and England or in English delftware It bears some relationship to the ovoid hexagonal teapots and wine-pots made in the late Ming and early Kangxi periods: cf. a teapot from the 'Hatcher Junk' wrecked between 1643–6 which also has panels containing Chinese figures[3]. The birds perched on rockwork are very similar to those seen on the 1705 coffee-pot (No.*17*) and the jar (No.*19*). As on the shoe (No.*20*), the decoration has suffered in the firing, with some blurring as a result of the running of the glaze.

The lid is a modern replacement. The shape of the finial appears to be based on those found on contemporary redware teapots.

h. 118mm; w. 188mm. Warren Collection. WA 1963.136.127

[1] Emmerson, *British Teapots and Tea Drinking*, 1992, Ch.1
[2] Dwight also experimented with 'white transparent stone' trying to imitate porcelain – unsuccessfully
[3] Sheaf and Kilburn, *The Hatcher Cargoes*, 1988, pl.89

Fig.5. Redware teapot Delft, Ary de Milde, late seventeenth century Purchased. WA 1999.513

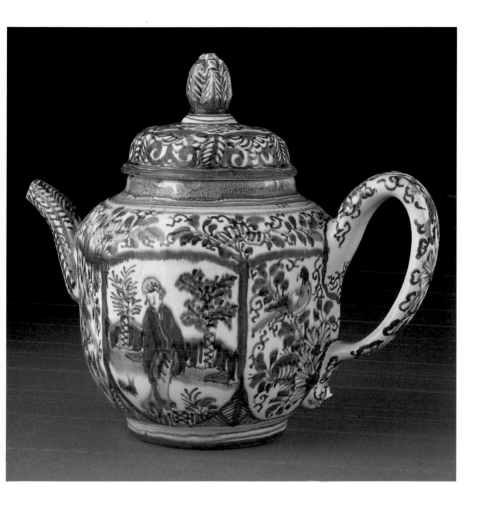

19 Jar
London, 1700–1715

The decoration on this jar represents the early eigh-teenth-century polychrome style at its best, both the main motif of a peacock in a rocky landscape and the scrolling border showing a bold, confident touch. It is a hybrid style, blending Chinese running borders with contemporary English decorative motifs such as the sponged trees of the Anglo-Dutch tradition (cf. No.15) or the peacock which appears on so-called 'farmhouse' plates of the period and which is close in feeling to the cock seen on the charger (No.7). Fragments found by Garner in Lambeth show similar hatched rockwork and sponged trees in reddish-brown and orange-yellow.

A jar of this precise shape decorated in mono-chrome blue with birds and Chinese floral sprays for-merly in the Lipski Collection is dated 1693 and another, of slightly flatter form, in the British Museum is dated 1696[1]. An even closer parallel can be drawn with a poly-chrome jar formerly in the Morgan Collection, also showing peacocks and rockwork[2]. All these vessels may once have had lids though none has survived, and they were presumably containers for some expensive com-modity. Lipski may be correct in calling them spice jars, but there is no documentary evidence for their use.

[1] Lipski & Archer, 1984, Nos.1546, 1547
[2] Archer & Morgan, 1977, No.44

h. 165mm; w. 156mm. Warren Collection. WA 1963.136.128

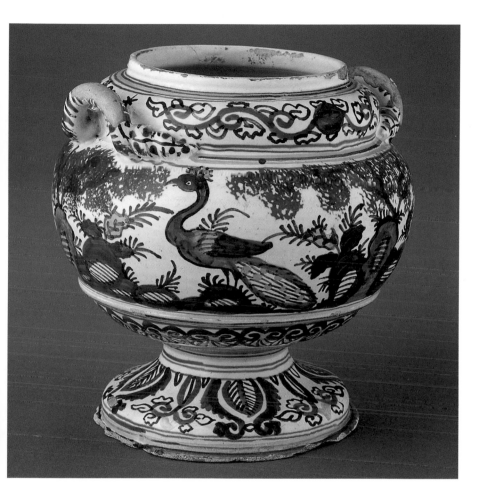

Model shoes

20 London. Inscribed (under the sole) A.H. 1707
21 London or Bristol, 1710–1730

A surprising number of delftware shoes of this kind have survived and saltglaze examples are also known. Lipski and Archer record forty-five examples with dates ranging from 1654 to 1768, and there are many undated examples. The fact that so many of them were made for particular people suggests that they were token of affection offered on a particular occasion, such as New Year's Day, especially those with the initials of an individual such as No.*20* or the unusual shoe in the Glaisher Collection, dated 1763, which has a panel depicting Cupid with a bow[1]. Those with the familiar triangle of initials indicating husband and wife were perhaps offered at a wedding, to judge from the part that shoes as symbols of good luck continue to play in the folklore of marriage. This is not to say that they were conceived simply as trinkets; they could have been used for posies of flowers or even for sweetmeats though they do not show signs of wear. Presumably they were always offered in pairs, of which several examples are known.

Model shoes of this kind were very popular in Holland, and many Delft examples are recorded. Dr de Jonge[2] mentions that the earliest known inventories in which they appear are of 1662 and 1663, but since the earliest English example is dated 1654, the tradition in Holland may go back even earlier. They were also made in France and Germany in the eighteenth century.

These shoes were made in a mould. The seventeenth-century English examples mostly have a large bow and a square toe and the floral decoration leaves large areas of white. Later shoes, which vary little from *c.*1710 onwards, usually have a moulded buckle, a pointed toe and an overall floral decoration on either side of a central band with floral motifs in reserve (No.*21*).The polychrome decoration on the first shoe (No.*20*) relates it to the tea-pot (No.*18*), both pieces showing a similar smudging of the detail through faulty firing. It probably comes from a London factory. The blue shoe may be from either London or Bristol.

[1]Lipski & Archer, 1984, No.1737
[2]*Oud Nederlandsche Maiolica en Delftsch Aardewerk*, 1947, p.236, Note 1, and *cf.* Pls.204, 205

20
h. 105mm; l. 159mm. Warren Collection. WA 1963.136.125

21
h. 165mm; l. 118mm. Warren Collection. WA 1963.136.126

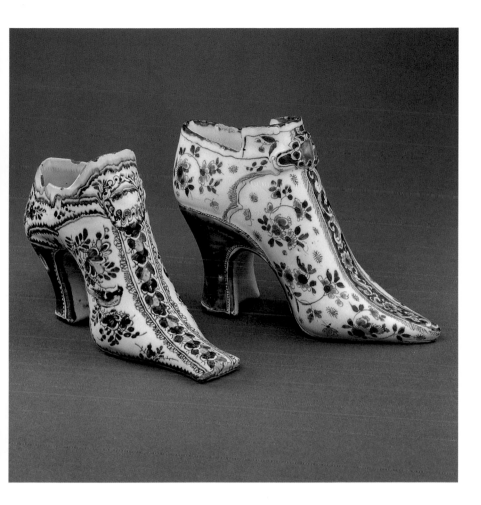

22 Dish
Probably Brislington or Bristol, 1710–1730

This dish is a particularly fine example of the kind of early eighteenth-century 'Chinese' decoration based on Kangxi export figures depicting figures from Chinese romances. The vase of flowers standing on a table is typical and can be seen, albeit in a slightly different form, on the well-known Carpenters' Arms bowl in the Bristol City Art Gallery, dated 1709[1], generally attributed to Thomas Frank's pottery in Bristol. The distinctive figures, found on a number of other pieces, are also characteristic of Bristol, notably a dish formerly in the Morgan Collection[2] where an identical female figure in red and green is seen sitting on a yellow cushion dotted in red, and where one of the flower-vases is painted in precisely the same way. The jumping boy also occurs on other pieces and seems to have been very long-lived, appearing on the Lambeth dish (No.47), which must date from the third quarter of the eighteenth century.

Other Bristol features are the border and the Q II Q motifs on the back of the dish, but it should be added that the motifs of the crossed swords and the grid have been found on fragments from both London and Brislington. The numerical mark is of uncertain interpretation.

[1] Britton, 1982, 10.27
[2] Archer & Morgan, 1977, No.44

d. 324mm. Mark: 19 6 10 3. Warren Collection. WA 1963.136.131

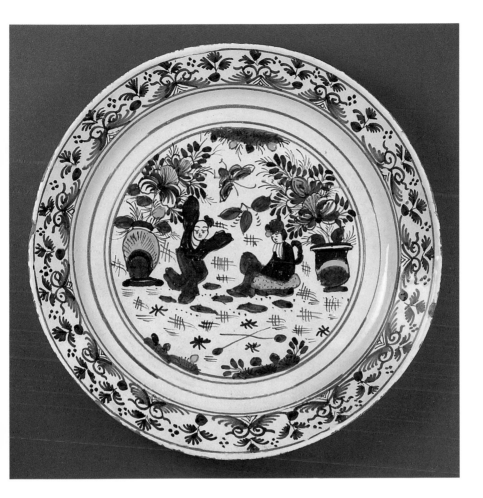

23–
24 Armorial delftware
London, 1728 and 1750

The finest early example of armorial ware is the large dish in the British Museum with a Ming border enclosing the arms of Elphinstone and Mostyn, made in Southwark in the second quarter of the seventeenth century, and a few pieces have survived from later in the century with the arms of distinguished families, notably the basket with the arms of Lyte dated 1676 (in the Victoria and Albert Museum)[1], but in general the upper classes ate off silver. In the eighteenth century the delftware potters had to compete with Chinese armorial porcelain , and relatively few delftware examples have survived[2]. These bear for the most part arms of the gentry: a plate in the Warren Collection (Fig.6) with the arms tentatively identified as those of the Meurig or Jefferies family of South Wales, is typical.

Lipski and Archer record fifty-seven seventeenth-century pieces with the arms of twenty of the London livery companies, mostly drinking vessels, but also chargers, plates and pill-slabs, with dates ranging from 1645 to 1697. There are thirty-one dated examples from the eighteenth century and several undated examples such as the plates with the Apothecaries' and the Basket-makers' arms in the Warren Collection[3].

The arms of the Company of Thames Watermen and Lightermen were granted in 1585. Seventeenth-century pieces with these arms include a tankard of 1663, a mug and caudle-cup of 1682, and a plate in the Warren Collection dated 1693[4]. On the large mug (No.23), which is inscribed on the handle I[S]A 1728, both the arms and the floral decoration are unusually well drawn.

The arms of the Pewterers' Company, granted in 1533, appear on a bottle of 1649 and on a Fécondité dish (after Palissy) dated 1655[5], but the plate (No.24) and its companion in the Bristol City Art Gallery[6], both inscribed on the base B[T]M 1750 are the only dated examples recorded from the eighteenth century. Britton, has identified the owner as Benjamin Townsend, a pewterer, who married Margaret Field at St Mary Aldermary on 23 December 1750. The two plates, doubtless part of a service, were presumably made to commemorate the occasion. They have a very unusual border.

[1] Archer, 1997, G.14
[2] In Dublin papers announcements offered 'sets with coats of arms, crests, done in the most elegant manner'
[3] Ray, 1968, Nos.38, 42
[4] Lipski & Archer, 1984, Nos.758, 784, 789: Ray, 1968, No.35
[5] In the British Museum: Lipski & Archer, 1984, No.103
[6] Britton, 1982, 10.35

Fig.6. Delftware plate Possibly the arms of Meurig or Jefferies Probably Bristol, dated 1753.
Warren Collection. WA 1963.136.35

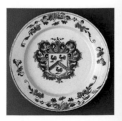

23
h. 152mm; d. 150mm. Warren Collection. WA 1963.136.36

24
d. 223mm. Warren Collection. WA 1963.136.39

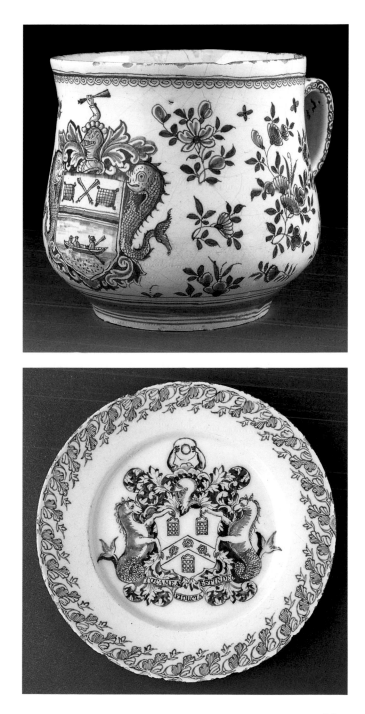

25–
26 Two plates – *Libertas Populi*
Bristol, 1734/5

In the Bristol election of 1734 the Tory candidate, Thomas Coster, standing on an anti-court platform, defeated the Treasury official, Mr Scrope. The city corporation, which had supported Scrope, petitioned parliament, claiming that many of the voters were not qualified and that there had been other irregularities, but after the Commons had heard the evidence, the petition was withdrawn and Coster later entered the city in triumph. The whole incident was accompanied by much propaganda on both sides and engraved portraits of Coster were produced and sold[1].

The first plate (No.*25*) is one of three examples showing the same figure of Justice with scales and sword trampling on a figure which can be identified from the verses accompanying the most elaborate of the three[2] –

Let Justice in each Honest Heart abide
And over Envy let her always ride.

The design clearly comes from an unidentified engraving, and on all three plates we find the inscription *Libertas Populi* (freedom of the people) and the initials 'TC' for Thomas Coster. On the plate in the British Museum the scroll reads 'The Petitions' rather than 'The Pollinn' (polling). Although these plates were made after rather than before an election, they are the earliest examples of 'election wares'[3].

The second plate (No.*26*), together with its virtually identical twin in the Bristol City Art Gallery[4], takes up the theme of parliamentary malpractice and, using the same figure of Justice, attacks the corrupting influence of 'Placemen' who, like Scrope, and other 'Pensioners', received financial benefit from the government and so were notoriously venal. Bills against them were introduced in 1730, 1734, and 1740 and thrown out, and it was not until 1743 that the 'Place Bill' was passed, ejecting some of the 'Venal Crew' (as a contemporary satirical print calls them).

The blue border is meticulously painted and perfectly set off by the neatly applied manganese powder-ground to produce one of the finest examples of this particular style of decoration.

[1] No example has survived. It is perhaps relevant to note that Coster had interests in the Cornish tin-mines, the source of the tin used by the Bristol potters.
[2] Ray, 1968, pl.8B
[3] For later wares see No.37
[4] Britton, 1982, 15.18

25
d. 213mm. Warren Collection. WA 1963.136.31

26
d. 229mm. The reverse with a pattern of X and II motifs and a mark- B. Warren Collection. WA 1963.136.32

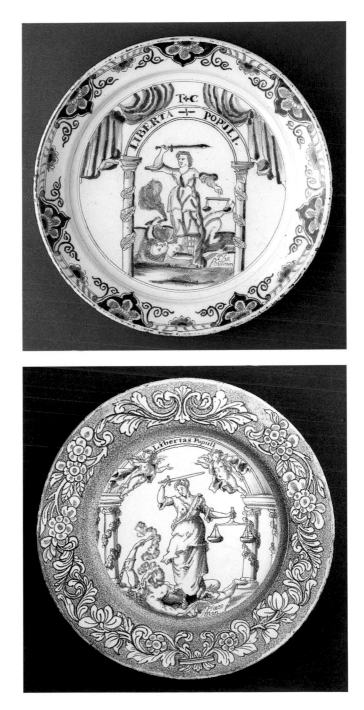

Historical events

27 Plate, The Taking of Portobello
Probably Liverpool, 1740–1743

Angered by the government's failure to respond to the Spanish insistence on searching British ships trading in the West Indies, Edward Vernon declared in parliament that with six ships he would take Portobello (Puerto Bello), the fortified trading post and base of Spanish coastguard fleet on the Isthmus of Darien. He was as good as his word, capturing Portobello on 21 November 1739 and, four months later, Fort Chagres in Panama, another important entrepot. At once he became a popular hero and commemorative pieces of all kinds were made. Most of them, such as this plate, show the capture of Portobello, but two large dishes dated 1740, the work of Joseph Flower, show the capture of Chagres[1].

The design is apparently connected with an engraving by W.H.Toms after a painting by Samuel Scott (in the National Maritime Museum) published in 1740/1. Other plates are recorded, all of them roughly following the same design[2], together with a remarkable bowl in the Manchester City Art Gallery, dated 1743, where it is accompanied by a lengthy inscription wishing good health to the crew of one of His Majesty's ships and their ladies[3].

An unusual feature of this plate and other dishes in the Fitzwilliam Museum and the Bristol City Art Gallery[4] is the border which is directly copied from a Chinese export plate with a bamboo, vine and grape design (Fig.7).

d. 213mm. Warren Collection. WA 1963.136.28

[1] Archer, 1997, B.11: Rackham, 1935, No.1568
[2] Another dish in the Warren Collection (Ray, 1968, No.27) is from a different print
[3] Lipski & Archer, 1984, No.1110
[4] Rackham, 1930, 1529: Britton, 1987: 10.48, 10.49
[5] Similar dishes are recorded: in the British Museum and the former Lipski Collection

28 Dish, The Duke of Cumberland
Probably Bristol, 1746–1750

William Augustus, Duke of Cumberland (1721–1765), son of George I – nicknamed 'Butcher Cumberland' – commanded the troops who defeated and massacred the Jacobite armies at Culloden. Anti-Jacobite feeling was very strong in England and the Battle of Culloden, which eliminated the threat to the throne, was a matter for great rejoicing, hence the inscription, unusually scratched into the powder ground round the rim of the dish, which reads – 'God save y[e] Duke of Cumberland Remember y[e] fighte of Cullodon'[5].

d. 337mm. Warren Collection. WA 1963.136.29

Fig.7. Porcelain plate Chinese, c.1730–45 Private Collection

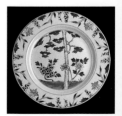

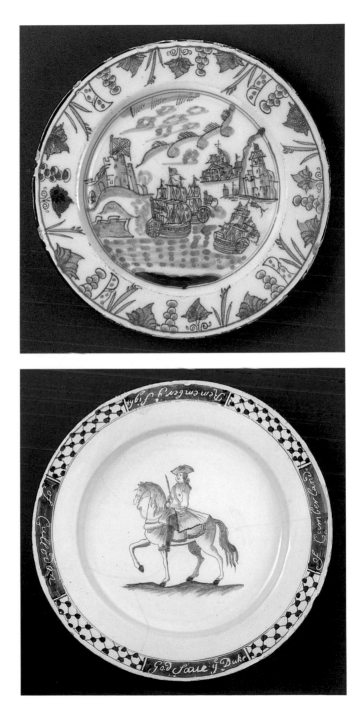

29 Punch-bowl. 'The Flower Bowl'
Bristol, dated 1743

This bowl has a special importance, not only because it is one of only three pieces of delftware which are clearly signed by the decorator, but also because it is probably in a literal sense a master-piece. Joseph Flower, a man of humble origins, was apprenticed to Richard Frank in the Redcliff Backs pottery, on 14 August 1736. On 19 March 1743, at the end of his apprenticeship, he became a burgess, and this bowl was evidently made in celebration of the event. Thereafter he became a pottery-dealer as is recorded in several documents[1].

Apart from this punch-bowl and the very similar bowl, unsigned, in the Bristol City Art Gallery[2], a number of pieces handed down in the family have been attributed to Flower. These include a large dish dated 1740 depicting the capture of Fort Chagres[3], and a plate depicting the Hot Well, Bristol, dated 1741/2: to these one must add the 'Voyage to the Moon' dish of 1740[4]. All have affinities with the bowl, not only in terms of glaze and colouring, but also in the somewhat laborious way in which the original engraving is transferred to the pot.

The scenes on the 'Flower Bowl' and on the version at Bristol, come from the *Musical Entertainer*, a collection of songs with engraved head-pieces by George Bickham and Gravelot first published *c*.1737–9[5] which is an important manifestation of the Rococo in English art. The young apprentice was clearly not at home in the style, substituting wreathed columns with capitals for the exuberant *rocaille* of the originals and rationalising the absurdities, but he was well able to copy Bickham's figures accurately by means of a transfer. A drinking scene, repeated on the inside (Fig.8) comes from a song called *Cato's Advice*, while the two lovers under a tree come from *The Relief – A Dithyrambick for two Voices*[6]. A notable feature of this bowl, not found on the Bristol version, is the musical score circling the rim. This, a round by Purcell, of 1681, to words by Thomas Otway[7] is one of very few pieces of music painted on delftware. One can only wonder at the difficulties involved in painting words and music on the inner rim of a bowl. Pountney states that Flower was a keen musician who often sang in concerts, which would suggest a personal involvement in the choice of songs selected.

d. 340mm; h. 213mm. Warren Collection. WA 1963.136.68

[1] Jackson & Price, 1982, p.106f
[2] Britton, 1982, 8.1
[3] See notes to No.27
[4] Lipski & Archer, 1984, Nos.468, 469, 478
[5] Ray, 1965
[6] For the other engravings see Ray, 1965 and 1968, pls 29–32
[7] Included in various contemporary collections but not the *Musical Entertainer*. It was later called *The Midnight Friendship*

Fig.8. The 'Flower Bowl' – interior

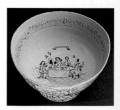

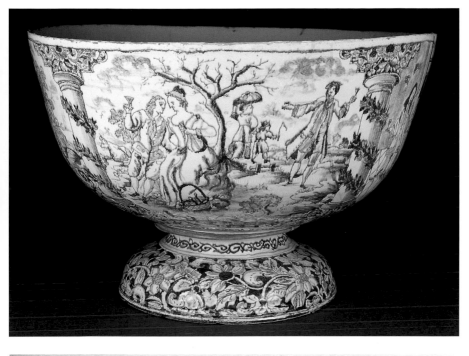

47

30 Barber's Bowl
Probably Bristol, 1740–1750

The form of the typical barber's bowl, with the half-circle cut out of the rim and the depression to one side – possibly a thumb-rest, possibly for a soap ball – clearly explains its function. The client held it under his chin while the barber applied the lather. Naturally such bowls were made in pewter and silver, and it is not known when they were first made in delftware, the earliest recorded dated example being one in the Hanley Museum, dated 1681[1]. They must have been very popular at the time, since the Pickleherring pottery inventory of 1699 mentions '2 doz small barbers basons' among the finished wares and no less than 375 'mean midle' and 'small midle Barber's basons' waiting for their first firing. Clearly these were household objects, to be brought out when the barber came to visit.

The most usual type of decoration on these pieces was a representation of the utensils used in the barber's trade: scissors, razor, combs, brushes and soap-balls, though one of 1706 shows a man with a horse, and one of 1719 shows a vase of flowers. Others, inscribed on the rim 'Sir your quarter is up' or 'Quarter Day Pray Gentlemen Pay'[2] may have belonged to a barber who presented his account quarterly. A more unusual bowl in the Bristol City Art Gallery has a *chinoiserie* landscape[3].

The Warren bowl is the most elaborately decorated of all surviving examples. The border, with its cherubs and floral scrolls in reserve on a deep blue ground is painted by a master hand in a style found on other delftware objects such as the 'Flower bowl' (No.*29*), though the farmstead in the centre is less well drawn. This type of reserve decoration was popular in the second quarter of the eighteenth century and is no doubt derived from Delft pottery.

d. 292mm; h. 92mm. Warren Collection. WA 1963.136.69

[1]Lipski & Archer, 1984, No.1218
[2]The latter on a bowl in the British Museum dated 1716. Lipski & Archer, 1984, No.1220
[3]Britton, 1982, 5.19

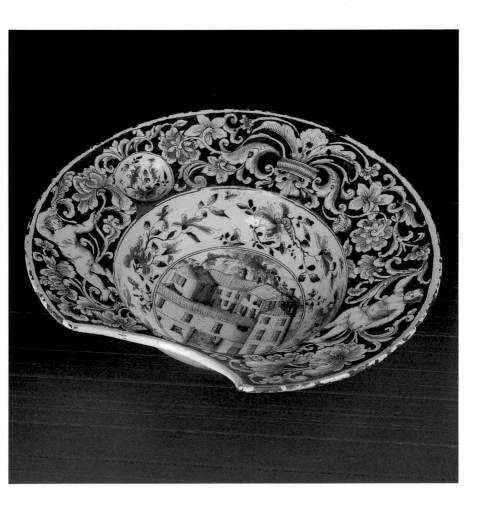

Chinoiserie plates

31–
32 Probably Liverpool, 1725–1750

The Transitional period in Chinese porcelain (c.1620–1662) saw a rapid development of stories derived from popular romances, and this trend continued in the reign of Kangxi. It is a world of fairy tales, of heroes and beautiful maidens acting out dramas, whose significance is now largely lost, in either a pavilion or a mountainous landscape setting[1]. In the final decades of the seventeenth century the Greek A factory in Delft produced some magnificent copies of such pieces, as can be seen in the collection assembled by William Blathwayte at Dyrham Park[2]. The English decorators lacked the skill to reproduce such fantasies, and generally speaking there seems to have been little attempt to do more than abstract one or two stylised figures. In those rare instances where a more 'Chinese' effect is aimed at, the result is clumsy[3]. This plate (No.31), therefore, though falling far short of Dutch examples, is an extremely rare survival.

The subject, clearly a misunderstood copy of some Chinese original, defies interpretation. The figure on the left is evidently a man of rank, towards whom a man of lower rank holds out a strange object watched by a lady with a fan. The setting with a pavilion with a striped roof supported on pillars with panels and a chequered floor is found on Chinese examples[4], one of which the decorator of this plate may have had before him.

By contrast the second plate (No.32), though retaining a certain Chinese quality, is closer to chinoiserie. A rough date for the design is provided by the plate at Colonial Williamsburg which is inscribed on the back I[H]M 1742[5], but neither this plate nor the others in the same collection has the mysterious inscription PURE STUF. This must be a reference to some commodity such as tobacco or snuff and was perhaps some kind of advertisement like the plate in the Reading Museum inscribed 'That's the shoe says Nan Sadler'. Austin also illustrates a bottle with the same design[6] and mentions that fragments of plates and a bottle have been excavated in Williamsburg. A notable feature of the group is the confident decoration done with a very fine brush.

[1] Sir Harry Garner, *Oriental Blue and White*, pls.66,69,72
[2] e.g. Ray, 1988, Fig.2
[3] e.g. Garner & Archer, pl.87B, 94C
[4] e.g. Sir Harry Garner, *op.cit.*, pl.66B, 72A
[5] Austin, 1994, No.251
[6] Austin, 1994, No.581

31
d. 292mm. The reverse with plant and sketchy 'grass' motifs under the rim. Reitlinger Gift. WA 1978.276

32
d. 220mm. The reverse with 'whiplash' motifs under the rim. Oppenheimer Bequest. WA 1961.57.15

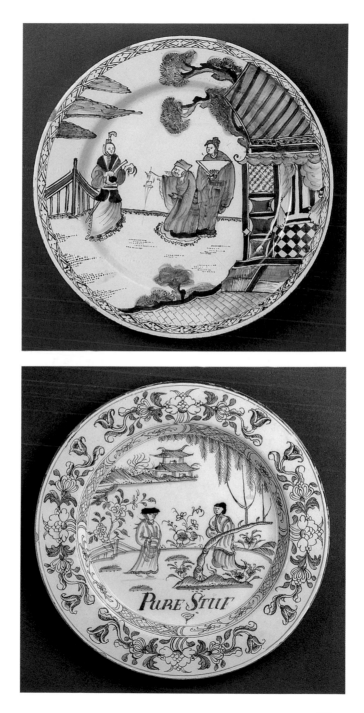

33 'Colander bowl'
Bristol. Inscribed J.F. 1751

It is not at all clear what this vessel was used for. Pountney suggested that it was a kind of strainer used in the preparation of hot punch, while others have suggested that it was used for growing watercress. The first is ruled out by the inevitable crazing and flaking which would occur if boiling-hot water came into contact with the tin-glaze; nor does it seem likely that the top would be so elaborately decorated if it was to be hidden by watercress. The pierced holes at the top might be suitable for flowers, but the concave top would be impractical for this purpose. The vessel is evidently a strainer, purpose unknown, with a wide aperture below the rim for pouring away the liquid[1]. At all events it is a very rare shape, of which only four examples have been recorded, this being the finest.

It is also of considerable interest, since it was an heirloom owned by the descendants of Joseph Flower in Bristol. Traditionally the initials J.F. have been interpreted as those of Flower, but this is doubtful, above all because if it was a family piece one would expect his wife's initial to appear in the customary triangular arrangement[2]. It is more likely that the bowl was made for someone else with the initials J.F. It has, however, strong Bristol characteristics such as the hard, shiny glaze and the somewhat laboured decoration in a blackish blue shading to pale blue, features which are found on the 'Flower bowl' and on other pieces from Redcliff Backs in these years.

The nearest comparison is with a bowl formerly in the Lipski Collection which has a typical Bristol landscape with sponged trees painted in a free manner[3]. The decoration on the Warren bowl is far more careful and at the same time more bizarre, with a fanciful *chinoiserie* landscape, on one side and a very English pastoral scene on the other (though the mountains strike a discordant note). This mixture is not untypical of eighteenth-century English delftware. The top is neatly decorated with each hole appearing as a flower enclosed by leaves.

d. 226mm; h. 86mm. Warren Collection. WA 1963.136.76

[1] Like a modern strainer for spinach
[2] For the problems connected with the Flower heirlooms see Ray, 1968, p.56f
[3] Sotheby's, 10 March 1981, lot 133

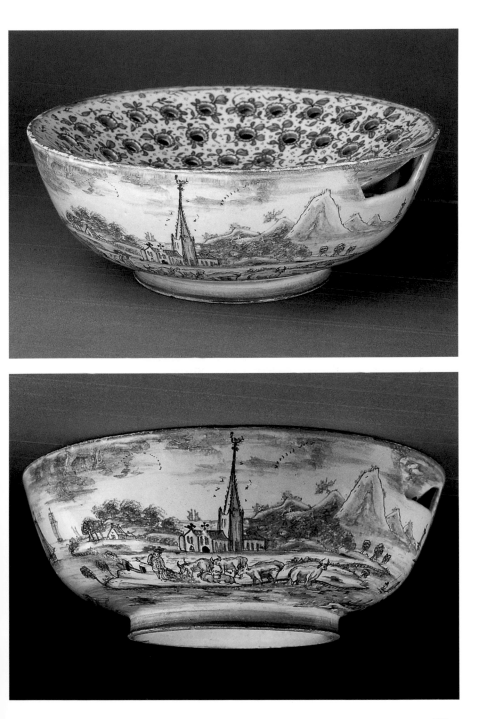

34 Puzzle-jug
Possibly London. Inscribed (under the base)
wGA 1745

The puzzle-jug has a long history going back to the Middle Ages and it was a vessel made by potters in many countries, in many types of earthenware. As will be seen, the unwitting drinker was faced with the problem of how to drink without spilling the contents over himself through the perforations. On many such vessels the challenge is issued in rhyme on the front and a number of such 'dares' are recorded. A puzzle-jug in the Warren Collection[1] has the words –

> From mother earth I claim my Birth
> Am made a Joke for man
> And now am here, fill'd with good cheer
> Come taste it if you can.

On others a wager is implied –

> What tho im common and well-known
> To almost every one in Town
> My purse to sixpence if you will
> That if you drink you some do spill.

Presumably taverns had such objects waiting for an unsuspecting customer.

The challenge could only be met by covering up all but one of the spouts and a small hole under the handle and then sucking the liquid out of the remaining spout. This involved making a hollow handle which linked the container with a hollow ring at the top of the vessel. The system created in the pot here illustrated is even more complex, since it has two hollow handles joined together and no less than seventeen spouts, many of them dummies. It is shown in cross-section by Crossley[2], who says that it is the only one of this type recorded. An example of 1733 in the Boston Museum[3] is of similar shape and has the same pierced 'bow-ties' on the neck, but it has a single handle.

This is also one of the finest decorated of all surviving puzzle-jugs, comparable with the well-known polychrome example inscribed John Keeling and dated 1742[4]. The Chinese landscape with a boy trying to catch a bird is admirably painted, and there is an intriguing contrast between the formal floral decoration in a reserve on a deep blue ground and the sketchy Rococo motifs enclosing the landscape.

h. 207mm; w. (max.) 147mm. Purchased. WA 1970.130

[1] Ray, 1968, No.114
[2] Trans ECC, Vol 15, Pt 1, 1993, p.83. Robert Crossley later presented the model to the Ashmolean
[3] Lipski & Archer, 1984, No.1024
[4] Lipski & Archer, 1984, No.1026

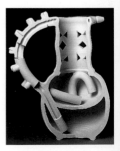

Fig.9. Crossley's model

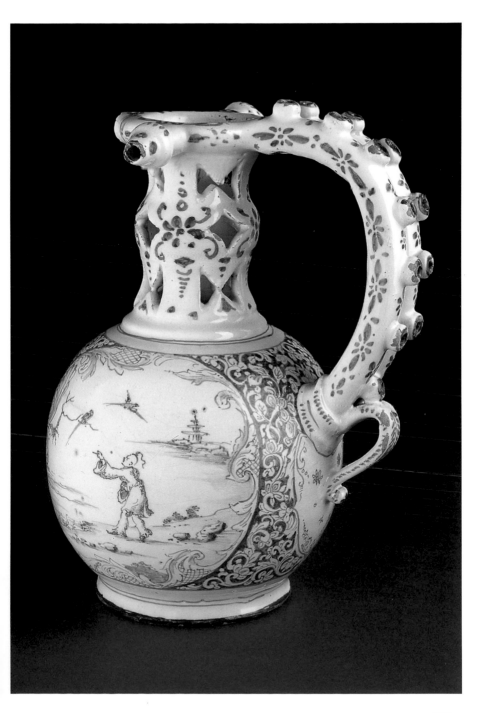

London *bianco-sopra-bianco*

35–36 A plate and a dish with Chinese landscapes
The plate, inscribed I¹s 1747
The dish, 1747–1755

The term *bianco-sopra-bianco* is used to describe a particular way of decorating a vessel with designs in white which stand out against the ground. The technique has antecedents in European pottery and glass[1], but its sudden revival appears to be connected with two particular types of decoration on early eighteenth-century Chinese export porcelain – underglaze carving, as seen on the plate (Fig.10) and overglaze motifs in shallow relief, as seen on the cup (Fig.11) dating from *c*.1750, which has London decoration in overglaze enamels.

The technique was evidently first revived at Rörstrand, in Sweden, the earliest known dated example being of 1745, and it seems likely that it was the Swedish potter Magnus Lundberg who brought the technique to England. Lundberg left Rörstrand some time in the 1740s and is next recorded as a pottery dealer in Bristol in 1750[2], but before then he may have worked in one of the Lambeth potteries.

This plate is one of the earliest known English examples of this technique[3]. Garner found shards of plates and an almost complete plate of this design in Lambeth, and the three surviving plates were almost certainly made there[4]. Britton suggested that the initials stand for John Jackson who married Sarah Cronk in St George's Chapel, Curzon Street on 26 June 1747. The decoration, with the Chinese riverscape and a garden with bamboo and an outsize peony is typical of the new style of Chinese decoration then coming into fashion, and is close in style to that on the Chinese plate here illustrated. The *bianco* border shows the six-petalled flowers and the Chinese scrolls typical of Lambeth.

The dish is undated, but was presumably made between 1747 and 1755, the latest recorded date on Lambeth wares with a *bianco* border[5]: it is apparently the only dish of this size to survive. The decoration of rocks, prunus, bamboo and birds is both lively and balanced, and painted by a master hand, and the *bianco* border is an expanded version of that seen on the 1747 plate.

[1] It is called *bianchetto* in Piccolpasso's sixteenth-century manuscript *Arte del Vasaio*
[2] See also No.45
[3] Lipski & Archer, 1984, No.509
[4] Hume (1977, p.101 and Fig.XVII No.8) records a chance find of a fragment in Southwark
[5] See No.37

Fig.10. Porcelain plate with a carved 'lotus' border
Chinese, *c*.1720–1750
Private Collection

Fig.11. Porcelain cup with relief decoration
Chinese, *c*.1725–1750: the flowers and insects added in London, *c*.1750
Gift of Anthony Ray FSA. WA 1999.510

35
d. 219mm. Warren Collection. WA 1963.136.192

36
d. 352mm. Oppenheimer Gift. WA 1961.57.6

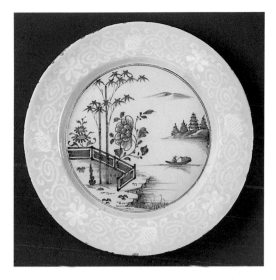

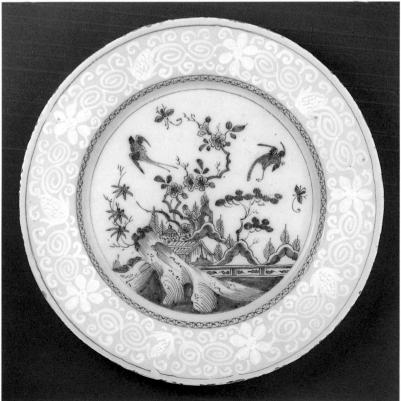

37 Bowl 'Wenman and Dashwood for Ever'
London (perhaps Lambeth High Street, William Griffith), dated 1755

Leaving aside the punch-bowl of 1724 in the Fitzwilliam Museum, which seems to commemorate the election, unopposed, of Thomas Bootle as member for Liverpool, the earliest known propaganda pieces associated with parliamentary elections are the *Libertas Populi* plates (Nos.*25* and *26*) of 1734, a bowl in the Bristol City Art Gallery inscribed 'Southwell for ever 1739', referring to a Bristol election[1], and a bowl at Wallington inscribed 'Let us drink success to Blackett and Fenwick', referring to an election in Newcastle in 1741. However, most surviving delftware pieces refer to elections in the 1750s, such as this bowl, one of two known examples[2]. Hogarth's engraving of an 'Election entertainment' (1755) shows these bowls filled with punch or other liquor in order to attract voters.

The Oxfordshire election of 1754 is famous in parliamentary history for the time it took to come to a decision: the campaign lasted nine months, the polling a whole week. There were four candidates – Philip, Viscount Wenman of Tuam and Sir James Dashwood Bt, standing for the Tories, and Thomas, Viscount Parker and Sir Edward Turner, standing for the Whigs. Wenman and Dashwood led in the votes, but because of the large number of unqualified voters who took part on both sides, the returning officer sent all four to the Commons, leaving Parliament to sort out the problem. After a year's debate the Tory majority was overturned and Parker and Turner duly represented Oxfordshire in Parliament.

Several objects have survived reflecting the widespread popular interest in this election, notably during the debate in parliament. Among these are a salt-glaze mug in the British Museum (G.120), inscribed in blue 'Wenman and Dashwood Old Interest for Ever No Double Return' (so protesting against the return of all four candidates), and a jug in the Ashmolean bearing the inscription 'Wenman and Dashwood for Ever say I, Friend, what say you?' (Fig.12).

The *chinoiserie* landscape on the outside of this bowl is typical of Lambeth and is often found with other inscriptions, notably variations of the invitation to take 'One more bowl and then…'- not to mention a fragment of a bowl at Williamsburg which reads '…the other bowl and then…'[3] (understandably a rare survival). The *bianco-sopra-bianco* border inside the bowl, found on many contemporary bowls, is typical of London.

d. 261mm; h. 117mm. Purchased. WA 1970.20

[1] Britton, 1982, 10.23
[2] The other is in the Victoria and Albert Museum: Archer, 1997, B.80. Two plates in the Ashmolean refer to the Tewkesbury election of 1754 and the Wootton Bassett election of 1757
[3] Austin, 1994, p.21, fig.27

Fig.12. Salt-glaze jug made for the Oxfordshire election of 1754–5 Staffordshire, 1755 Purchased. WA 1970.20

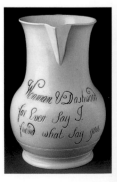

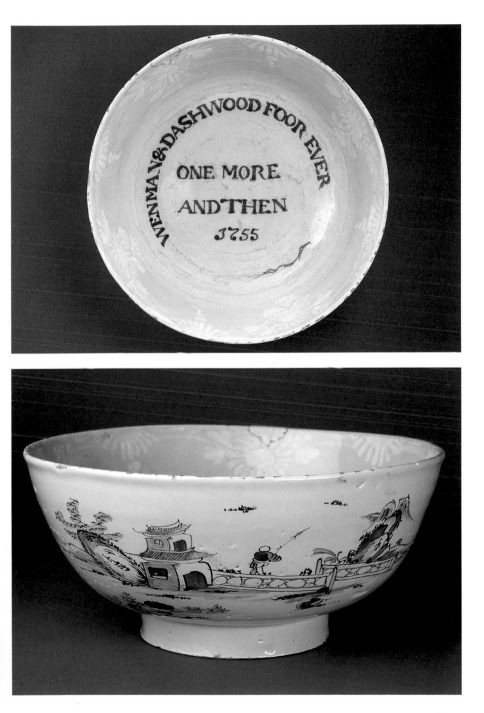

38 Pill-tile
Factory uncertain, *c.*1750

Pill-tiles, sometimes called pill-slabs, are a peculiarly English form, and they were evidently made in all the main delftware centres, which makes an attribution difficult. All of them have holes for suspension and, although some of them show signs of wear, indicating that they had been used for rolling pills or mixing powders, the majority appear to have served as a badge to proclaim the fact that the owner was a freeman of the Society of Apothecaries of London whose arms form the main decoration of all surviving examples, apart from the earliest dated example. These arms, as granted by the College of Arms in 1617 include a shield with the figure of Apollo, the 'inuentor of physique', supported by unicorns and with a rhinoceros as crest, together with the motto *opiferque per orbem dicor* ('I am called help-bringer throughout the world', a quotation from the story of Apollo and Daphne in Ovid's *Metamorphoses*). On many examples there is an oval with the arms of the City of London below the shield, perhaps indicating a metropolitan owner and so a London provenance.

The tiles are of various shapes, predominantly octagonal but sometimes heart-shaped, shield-shaped or round, and decorated in monochrome blue, with some examples having touches of green or yellow, or the inscription in manganese: only seven polychrome pill-tiles have been recorded[1]. Matthews[2] records six variants of the basic design, and dated examples range from 1664 to 1704: (two earlier ones dated 165?[3] and 1663 do not have the arms, and an incised date 1785 on the back of a later example is unreliable).

The same arms occur on other wares such as drug-jars, as one would expect, but there are also four plates which bear the arms. One of them in the Warren Collection[4], together with its pair in the Saffron Walden Museum, is decorated in blue and probably of Bristol manufacture; two of them, in blue but with a manganese powder-ground, are documentary pieces from the Wincanton factory and dated 1738[5].

h. 300mm; w. 247mm. Andrade Gift. WA 1968.345

[1] One example is in the Oxford Museum of the History of Science
[2] Matthews Trans ECC Vol 7, Part 3, 1970, p.200
[3] Lipski & Archer, 1984, Nos.1675 (the last figure of the date is missing) and 1676
[4] Ray, 1968, No.38
[5] Lipski & Archer, 1984, Nos.426, 426A

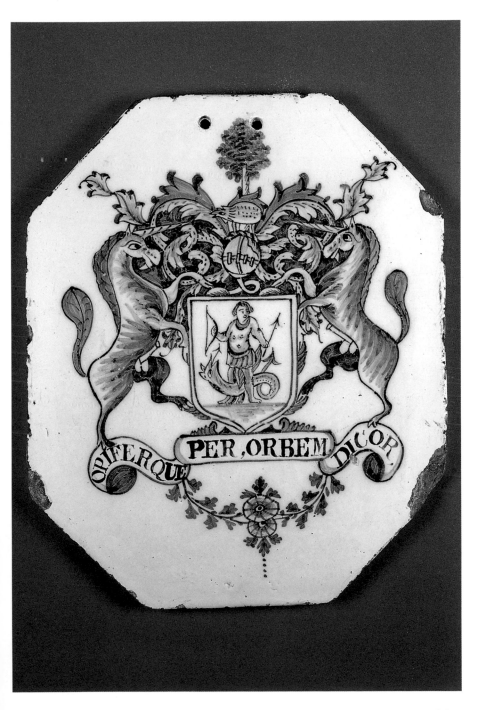

39 Plaque with a landscape
Liverpool, 1750–1760

As the two pierced holes indicate, this plaque was made to hang like a picture on a wall. There seems to have been a vogue for this kind of ceramic decoration in the eighteenth century, but delftware examples are rare. From the first decade of the century there are oval plaques depicting Queen Anne and Prince George of Denmark, a rectangular plaque showing Anna-Sophia of Hanover, and a notable plaque with a pastoral scene, among others[1]. From the 1730s are plaques depicting the Monument and a grinning face[2]. Fewer examples are recorded from the second half of the century and the Ashmolean plaque is the only one of its kind.

This kind of landscape appears on many Liverpool bowls, dishes, plates and flower-bricks of the third quarter of the century; e.g. the Wyatt of Applesham bowl in the British Museum, dated 1754[3], which has very similar buildings and trees, also in polychrome, and the monochrome blue bowl in the Warren Collection[4]. Many Liverpool plates and flower-bricks are similarly decorated.

[1] Lipski & Archer, 1984, Nos.1684–1688
[2] Lipski & Archer, 1984, Nos.1693, 1694
[3] Lipski & Archer, 1984, No.1141
[4] Ray, 1968, No.94

w. 372mm; h. 245mm. Reitlinger Gift. WA 1978.269

40 Sauce-boat
Probably Liverpool, 1750–1775

The shape is derived from a silver original, probably
French in origin, the earliest known example being in
Huguenot silver of 1717. At about this time the shape
was copied in Delft and one such piece, or a silver orig-
inal, was sent to China where it was copied in blue and
white porcelain[1], The shape was also copied in Worces-
ter – cf. the sauce-boats in the Marshall Collection[2] –
and it is perhaps from Worcester that the Liverpool
delftware potters got their inspiration.

The rustic scene, with a peasant couple watering
an assorted collection of animals, is painted with great
delicacy and in a style comparable with that seen on a
pair of similar vessels formerly in the possession of
Jonathan Horne[3], where a man is seen driving cattle in
a similar landscape. This kind of decoration can cer-
tainly be attributed to Liverpool. Other examples have,
inside, floral decoration, a bird on a branch, or a coat-
of-arms, but common to nearly all of them are the han-
dles in the shape of a fox and the decoration of the
exterior, which has reserve panels on the pointed ends
separated by a 'Chinese' floral spray and a band of dia-
per on the flat flange. Evidently all were taken from
moulds, presumably from an English silver original.

l. 213mm; w. (overall) 197mm; h. 64mm. Warren Collection.
WA 1963.136.93

[1] An example is at
Dyrham Park
[2] Nos.1017 (Fig.13) and
855
[3] Horne, *Collection*, Part
VIII, 1988, No.198

Fig.13. Porcelain sauce-
boat
Worcester, c.1760
Marshall Collection.
WA 1957.24.1017

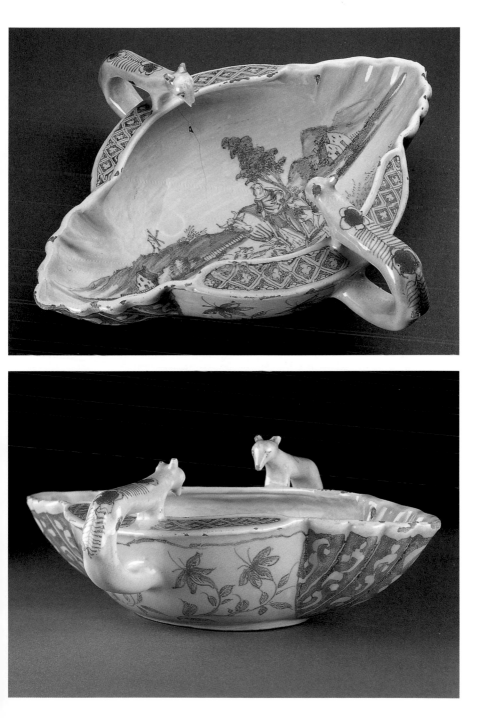

41 Teapot
Liverpool, c.1760

As mentioned above, the early eighteenth century saw a rapid growth in tea-drinking[1] and it soon became a universal necessity rather than simply a fashion among the rich. By the 1740s it had become the staple drink of the working classes, replacing ale, and this in spite of the sharp rise in taxes. By the end of the century it had become the national drink.

The rise in tea-drinking naturally led to a demand for serving vessels such as tea-caddies[2], cups and saucers, milk jugs, sugar-bowls, spoon-trays, and slop-basins, examples of which are known in delftware. Tea-pots were also made but, as has already been mentioned, ordinary delftware is not a suitable type of pottery for serving very hot liquids, and relatively few teapots have survived for this reason. A correspondent in the *Gentleman's Magazine* for April, 1763, wrote – 'the same cause (i.e. heat) that makes the glazing crack, makes it also scale off after it is cracked, which is universally the case with all earthenware, particularly that called Delft.' As in the earlier part of the century, silver teapots would have been more common, or, of course salt-glazed stoneware teapots which, being fired at a higher temperature, were less fragile. Recognising the advantages of stoneware the Liverpool potters introduced a hybrid – tin-glazed stoneware, which would have the attraction of delftware and the durability of stoneware: an example is in the Warren Collection[3]. Shards of this ware were found on the site of Alderman Shaw's pottery off Dale Street in Liverpool.

This teapot (No.41) is made of ordinary delftware and has survived remarkably well. In shape it is very similar to other Liverpool teapots of the period, but has a rather more pointed knop and a moulded spout. The decoration represents English *chinoiserie* at its best. The deer with bent legs are copied from those often found on Chinese porcelain, notably in the design known as the 'Hundred Deer', and they appear on other Liverpool wares. Exceptional for this date is the fact that it is decorated in polychrome, nearly all other recorded examples being painted in monochrome blue.

[1] See No.18
[2] e.g. Nos.42–43
[3] Ray, 1968, No.96

h. 140mm; w. (overall) 200mm. Warren Collection.
WA 1963.136.173

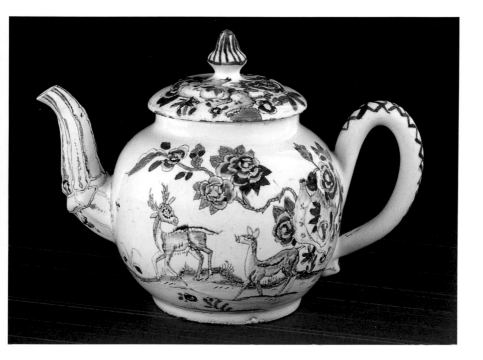

42–
43 Tea-caddies

Tea, which became such a fashionable drink in the eighteenth century was an expensive commodity and was usually kept under lock and key, to be dispensed when necessary by the mistress of the house. The vessels of the type shown here were undoubtedly used for tea, like a pair at Williamsburg, dated 1750 and inscribed 'Bohea Tea' and 'Green Tea'[1], or one formerly in Jonathan Horne's possession on which two faces have bands issuing from their mouths inscribed 'Fine Tea' and 'Beste Thee'[2], and were perhaps kept in a lockable box. A great many delftware examples have survived, with dates ranging from 1727 to 1774. These are decorated in many different styles, and it is clear that a great deal of care was taken over their decoration, especially the inscribed pieces. Most of them are rectangular, with chamfered corners, but some are round. Originally they must all have had ceramic lids but few of these have survived.

The first tea-caddy (No.42), which, unusually, has a lid[3], is probably from Richard Frank's factory in Bristol. It shows an elegant gentleman on one side and a lady on the other, with reserve panels on a diaper ground containing Chinese flower-sprays. Identical figures, presumably from the same transfer, can be seen on a caddy in the Burnap Collection[4] and on one in the British Museum, and similar figures, but less well drawn, occur on another tea-caddy in the Warren Collection and on one in the Glaisher Collection[5].

The second (No.43) was probably made in Liverpool whose potters seem to have specialised in neat *chinoiserie* figures of this kind. The decoration consist of four panels with Chinese scenes, the chamfered corners with alternately diaper pattern and rococo scrollwork, the latter partly repeated on the top. The whimsicality of the figures and the interpretation of the Chinese mountain landscape are wholly typical of that delightful vision of Cathay which was an essential part of rococo decoration, as are the C-scrolls.

[1] Austin, 1994, No.128
[2] Horne, *Collection*, Part VI, 1986, No.139
[3] Perhaps from another, similar vessel
[4] Taggart, 1967, No.161
[5] Ray, 1968, No.102: Rackham, 1930, No.1537

42
h. 127mm; l. 99mm; w. 73mm. Warren Collection. WA 1963.136.101

43
h. 104mm; l. 78mm; w. 60mm. Jahn Bequest. WA 1967.45.20

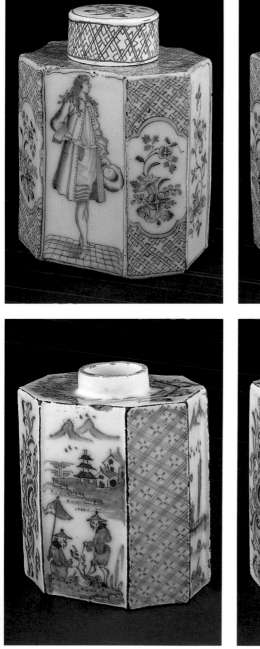
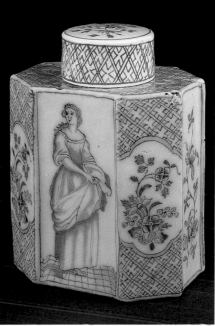
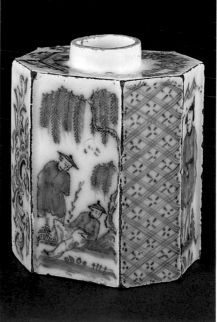

Bristol landscapes

44 Plate
1750–1770

In about 1750 a hint of Gravelot and Gainsborough appears in Bristol landscape designs, notably in the Redcliff Back pottery. Elegant figures, somewhat elongated in the rococo manner, stroll in an open landscape dominated by tall trees with sponged foliage. Clearly there were several decorators who interpreted the style in different ways. One of these was a mysterious pot-painter named Bowen who in 1761 signed a plate, now lost, of which only an unreliable engraving in a book is known[1]. The present plate (No.*44*) is very different in character. It has a very pleasing sense of space and of perspective achieved by the gradations of colour. Another plate in the Warren Collection, depicting a man with his daughter and a dog, is evidently from the same service and perhaps by the same hand[2]. On both the use of a transfer can be detected in the identical outline of the mounds to the right and the line of hills to the left, but the rest of the decoration has been added free-hand, perhaps from a pattern-book.

[1] For which reason it is impossible to talk about a 'Bowen style'. The Bowen plate is painted in blue and manganese, an unusual combination in Bristol. The engraved illustration is reproduced in Ray, 1968, fig.13A & B and Lipski and Archer, 1984, No.619.
[2] Ray, 1968, No.79
[3] See No.*35*
[4] Charleston, 1963
[5] cf. Ray, 1968, pl.45
[6] Ray, 1968, p.92f. A *chinoiserie* plate in the Warren Collection (No.172: Fig.14) is dated 1764

d. 229mm. Warren Collection. WA 1963.136.80

45 Plate
1760–1770

Charleston has shown that in 1767 Magnus Lundberg[3] was a master in what was almost certainly the Redcliff Back pottery, where he probably painted the ship and the Swedish inscription inside a bowl dated 1757 – hence his signature under the base - though the outside shows a Bristol landscape by another hand[4]. The bowl has no *bianco* enrichment, but this appears on other ship-bowls commissioned in Bristol by visiting captains from the Baltic ports, and it seems certain that he brought the technique with him from London. The design seen on No.*45* is often found on Bristol pottery and tiles[5], and the *bianco* border, set off by the lavender-blue ground, includes the typical Bristol 'pine-cone'. There are several dated examples from the 1760s (e.g. Fig.14)[6].

Fig.14. Plate with *bianco-sopra-bianco* decoration Bristol, dated 1764 Warren Collection. WA 1963.136.172

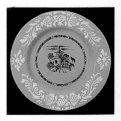

d. 226mm. Warren Collection. WA 1963.136.90

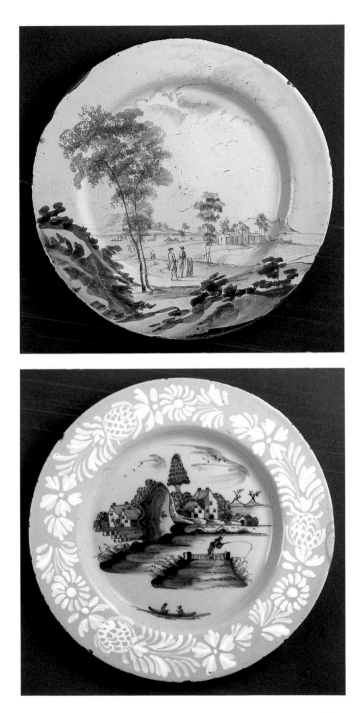

46 Dish with a *chinoiserie* decoration
Perhaps Liverpool, 1760–1775

The prime evidence for the use of *bianco-sopra-bianco* at Liverpool is to be found on certain tiles with *chinoiserie* subjects taken from the *Ladies' Amusement*[1] which are found in identical form on other Liverpool tiles. On these the tin-glaze has a distinctive greyish-blue or pinkish tone and the *bianco* design, unique to these tiles, is barely perceptible to the touch.

This dish has the same kind of dull glaze as the tiles into which the thin *bianco* border melts, rather than standing out as it does on the Bristol examples such as the plate (No.*45*). The very delicately painted border design appears to be unique, but certain elements such as the floral motif with hollow rather than solid petals, are found on plates with 'Fazackerley' flowers[2] which may also be Liverpool, and in its free design it relates to a plate in the Victoria and Albert Museum[3] which may also be Liverpool rather than Bristol. The reverse has the 'herbal sprigs' under the rim which Britton associates with Liverpool[4]. Other polychrome dishes with *chinoiserie* designs and *bianco* enrichment are known, but none of these is decorated in the distinctive style seen here, with the palette dominated by the coral-red of the tree set off by the yellow.

d. 336mm. Oppenheimer Bequest. WA 1961.57.3

[1] Ray, 1982, pl.79 g-l
[2] e.g. Ray, 1968, No.112
[3] Archer, 1997, B.91
[4] Britton, 1982, p.256, 313

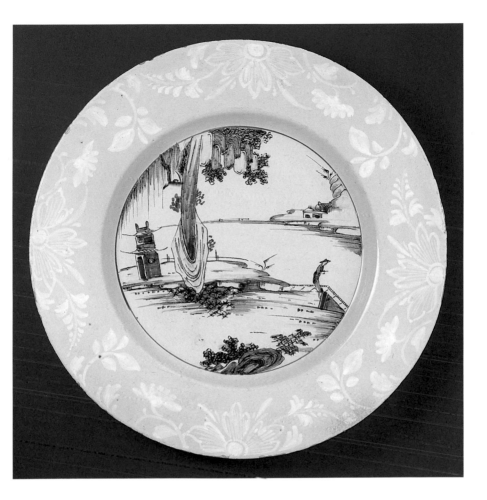

47 Plate
Liverpool, *c*.1760–1775

In the 1760s the Liverpool delftware potters, like their counterparts in the Liverpool porcelain factories, created some of the most attractive *chinoiserie* designs found on pottery. Unlike certain designs on tiles they do not owe anything to the *Ladies' Amusement*, nor indeed to the fantasies of Pillement. Apparently they took individual figures from Chinese porcelain together with landscape elements, notably the rocks, and the flowers, and created out of them something very individual. It is above all the simplicity of the designs which is so striking, together with the neatness of the brushwork. This plate is one of the most attractive examples of Liverpool *chinoiserie* whose effect is greatly enhanced by the delicate polychrome decoration and the admirable balance of the design; note especially the way in which the curve of the figure is echoed by the plant. The 'Chinese' figure reminiscent of certain figures on Liverpool tiles of the period, holds a fanciful staff set with leaves, bells, and what appear to be grapes, and the blend of *chinoiserie* landscape and European flowers is typical.

[1] Archer & Morgan, 1977, No.45
[2] *Bow Porcelain*, 1981, pl.88A, B

d. 226mm. Warren Collection. WA 1963.136.176

48 Dish
Lambeth, 1750–1775

The Lambeth potters produced a great variety of *chinoiserie* designs, none of them more attractive than the boy seen here excitedly stretching out to catch an insect flying above his head. This figure is derived from Chinese porcelain and occurs on earlier types of London *chinoiserie* such as the dish (No.*22*) or the polychrome jar formerly in the Morgan Collection[1]. At a later date it became known as the 'jumping boy' and is often found on English porcelain. Adams[2] illustrates a Chinese plate and a Bow derivative with a similar figure, and it also appears on Liverpool (Chaffers) porcelain.

d. 352mm. Reitlinger Gift. WA 1978.283

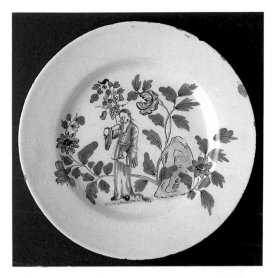

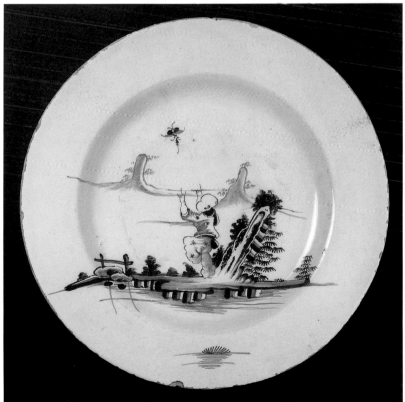

49 Bottle
Probably Liverpool, 1750–1770

Bottles with a basin *en suite* which could be placed in a washstand were made in all the factories, but above all in Liverpool, in the third quarter of the eighteenth century[1]: in a Delftfield advertisement of 1757 they are listed as 'bottles and basons'. Not many complete sets have survived but there are two examples in the Bristol City Art Gallery[2]. It is of course possible that the individual bottles which have come down to us, of which there are three examples in the Warren Collection[3] could also have been used for serving water or wine at table, but the evidence is lacking.

Many of these bottles are decorated with *chinoiserie* flowers, but landscapes are also found and a magnificent Liverpool bottle in the Bristol City Art Gallery is decorated in polychrome with exotic birds[4], while a very rare bottle in the Glaisher Collection has *chinoiserie* scenes done in overglaze enamels[5].

The landscape seen here is very finely painted in a style which is associated with Liverpool, the typical elements being the fisherman on an estuary, the buildings and the ruins which are often found on Liverpool pottery and tiles at this time. On the other side is a smaller 'Chinese' landscape with a pavilion. A bottle in the Victoria and Albert Muscum[6], of slightly more rounded shape, is virtually identical, though naturally with minor variations in the detail.

Although the attribution to Liverpool is likely to be correct, one should bear in mind that decorators from Liverpool were employed by Henry Delamain's in the Dublin factory in the 1750s. However no Dublin bottle of this shape is recorded and the Dublin blue tends to be brighter.

h. 248mm; w. 159mm. Warren Collection. WA 1963.136.92

[1] Archer (1997, p.274, illustrates such a washstand in the VAM
[2] e.g. Britton, 1982, 6.35 & 8.46: 15.2 & 15.3
[3] Ray, 1968, Nos.178, 183 and the present example
[4] Britton, 1982, 6.27
[5] Rackham, 1935, No.1727
[6] Archer, 1997, E.18

50 'Argyle'
London, 1760–1780

This unusual vessel, is a gravy-server. It was apparently the invention of the third Duke of Argyle (1682–1761) and was first made in silver, the earliest recorded example bearing the hall-mark for 1755. A number of silver 'Argyles' survive from the 1760s but this is the only known example in delftware. Like the puzzle-jugs, this was a very complex piece to make. It consists of two compartments, one above the other: the upper one held the gravy, while the lower one was filled with hot water through a tube in front of the handle.

[1] Archer, 1997, B.265 and Fig.34: B.14 and Fig.30

The floral decoration is very typical of the Lambeth potteries in the second half of the eighteenth century, painted in a dark smoky blue which is rough to the touch where it is too thickly applied.

h. 169mm; w. (overall) 159mm. Warren Collection.
WA 1963.136.117

51 Sweetmeat dish
London, 1760–1780

The Lambeth potteries continued to operate for some years after the decline in the manufacture elsewhere, producing well potted and well painted wares in a variety of styles including late versions of the earlier landscape style. This unrecorded, and apparently unique dish is perhaps the masterpiece of this period, showing remarkable subtlety in the handling of perspective by using two shades of blue, and a sense of repose in the depiction of a tranquil landscape with a pedlar. Typically the rest of the decoration is a mixture, with a hint of the Rococo in the shell motif and of Chinese porcelain in the formal border. The late date is suggested by the general similarity to the well-known plates with a shepherdess and swain related to a print of c.1770 by Cuvilliès, and by the leafy tendrils which appear also on plates depicting Admiral Keppel after a print dated 1779[1]. The elegant shape, with its neatly scalloped rim is also unrecorded.

d. 227mm. Reitlinger Gift. WA 1978.247

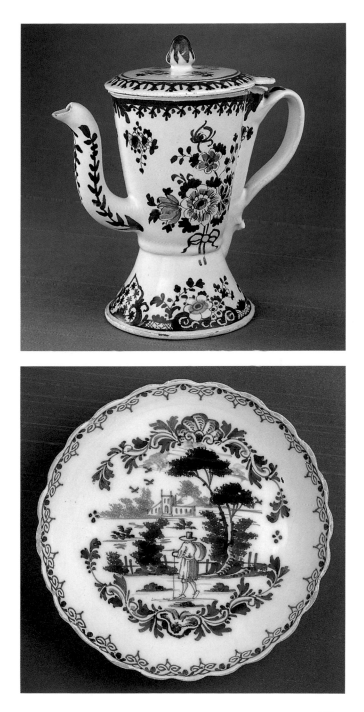

Select bibliography

(For the most recent full bibliography see Archer, *Delftware*, 1997, p.606f)

Archer 1982. Michael Archer, 'The Dating of Delftware Chargers' in *Transactions of the English Ceramic Circle*, Vol.11, Part 2, pp. 112–121.

Archer 1997. Michael Archer, *Delftware*, a catalogue of the collection in the Victoria and Albert Museum, London.

Archer & Morgan 1977. Michael Archer and Brian Morgan, *Fair as China Dishes – English Delftware*, Washington.

Austin 1994. John Austin, *British Delft at Williamsburg*, Williamsburg and London.

Britton 1982. Frank Britton, *English Delftware in the Bristol Collection*, London.

Britton 1987. Frank Britton, *London Delftware*, London.

Charleston 1963. Robert Charleston, 'Bristol and Sweden: Some Delftware Connections' in *Transactions of the English Ceramic Circle*, Vol. 5, Part 4, pp. 222–234.

Garner & Archer 1972. F.H.Garner and Michael Archer, *English Delftware*, London.

Horne Collection. Jonathan Horne, *A Collection of Early English Pottery*, London (ongoing).

Hume 1977. Ivor Noël Hume, *Early English Delftware from London and Virginia*, Williamsburg.

Jackson & Price 1982. Reg and Philomena Jackson and Roger Price, *Bristol Potteries*, Stoke-on-Trent.

Lipski & Archer 1984. Louis Lipski and Michael Archer, *Dated English Delftware*, London.

Rackham 1935. Bernard Rackham, *The Glaisher Collection of Pottery and Porcelain*, Cambridge.

Ray 1965. Anthony Ray, 'The Flower Bowl and the Musical Entertainer', *The Connoisseur*, Vol. CLX, pp. 232–235.

Ray 1968. Anthony Ray, *English Delftware Pottery in the Robert Hall Warren Collection*, London.

Ray 1982. Anthony Ray, 'Delftware Diversions' in *Transactions of the English Ceramic Circle*, Vol. 11, Part 2, pp. 153–160.

Ray 1988. Anthony Ray, 'Dutch Delft at Dyrham' in *Country Life*, 13 October 1988, pp.236–238.

Taggart 1967. Ross Taggart, *English Pottery in the William Rockhill Nelson Gallery*, Kansas City.